CENTRAL OHIO
LEGENDS & LORE

CENTRAL OHIO
LEGENDS & LORE

JAMES A. WILLIS

THE
History
PRESS

Published by The History Press
Charleston, SC
www.historypress.net

Front cover, top left: author photo; *top center*: author photo; *top right*: author photo; *bottom*: Little
City of Black Diamonds/New Straitsville History Group.
Back cover: Little City of Black Diamonds/New Straitsville History Group; *insert*: courtesy of
Thurber House.

First published 2017

Manufactured in the United States

ISBN 9781467136686

Library of Congress Control Number: 2017931821

Notice: The information in this book is true and complete to the best of our knowledge. It is
offered without guarantee on the part of the author or The History Press. The author and
The History Press disclaim all liability in connection with the use of this book.

This book is intended as entertainment and as a historical record of Ohio ghost stories,
legends and folklore. Many of these stories cannot be independently confirmed or
corroborated, and the author and publisher make no representation as to their factual
accuracy. Readers should be advised that some of the sites described in this book are located
on private property and should not be visited, or they may face prosecution for trespassing.

Steve and Carol Flee—For love, support and for continuing to trust such a strange and spooky guy with their daughter.

CONTENTS

CONTENTS

ACKNOWLEDGEMENTS

Taking a closer look at how history and folklore can live side-by-side is often a daunting task. This book would not have been possible without the help and support of so many people, including Shirley and the staff of the J.E. Reeves Victorian Home and Carriage House Museum, the Dover Historical Society, Valda Lewis, Little Cities of Black Diamonds/New Straitsville History Group, Cheryl Blosser, Todd James Dean for unearthing the Stuart Pierson pic, Anne Touvell, Thurber House, Amanda Irle at The History Press, Heather O'Kronley, Dick Hoffman for the Camp Chase pics, Mark Moran and Mark Sceurman for being the first ones to allow me to explore my weird side and my paranormal peeps at the Ghosts of Ohio.

And last, but certainly not least, none of this would be possible without the love and support from Stephanie and Courtney, both of whom can still melt me with a single smile.

PART I

FAMOUS GHOST STORIES

Camp Chase Confederate Cemetery

There is a long-standing legend surrounding Columbus's Camp Chase Confederate Cemetery. Folks say the place is haunted. At first glance, the idea of a cemetery being haunted is nothing new: graveyards around the world are said to be haunted. What makes the ghost stories associated with Camp Chase unique? For starters, while many people have seen the ghost of a woman here, no one knows who she is. But the most intriguing aspect of the legend is the historical facts regarding how so many Confederate soldiers came to be buried in Ohio.

With the outbreak of the Civil War in April 1861, President Lincoln put out the call for men in Union states to rally and enlist in the army to help defeat the Confederates. Ohioans who enlisted were originally sent to train at Columbus's Camp Jackson. But the number of Ohio men willing to take up arms was so great that Camp Jackson was quickly overcrowded. The following month, construction quickly began on another training facility near Camp Jackson. Within weeks, 160 houses for the trainees were built. Camp Chase officially opened on June 20, 1861. The facility was named after former Ohio governor Salmon P. Chase, who was also President Lincoln's treasury secretary.

In addition to the houses and facilities for the Union men, a small area in the southeast corner of the camp was set aside for use as a prison facility. The stockade and buildings inside were designed to hold approximately 450 prisoners. Historians believe the creation of this stockade was a bit of an afterthought and that the primary function of the facility was to train men entering the Union army. That would soon change.

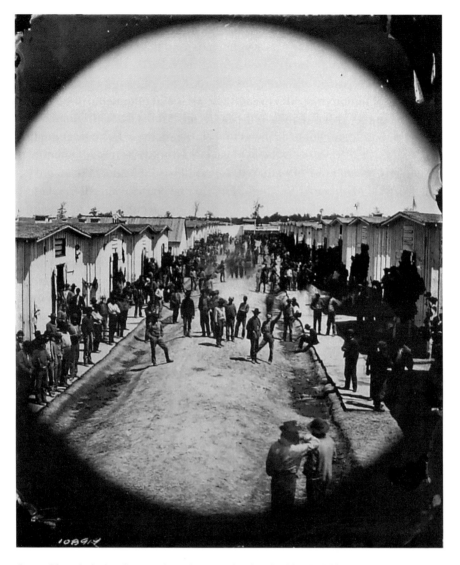

Camp Chase in its heyday, seen in a photograph taken by Manfred Marsden Griswold, allegedly through a hole in the fence. *National Archives.*

In February 1862, an estimated eight hundred Confederate prisoners were sent to Camp Chase, immediately doubling the number of prisoners the stockade was designed to hold. Thought was given that only enlisted men and noncommissioned officers should remain at Camp Chase and that all Confederate officers be sent to other facilities, including the Confederate Stockade on Lake Erie. This was attempted, but Camp Chase continued to

swell as more and more captured Confederates arrived. By the following year, there were close to eight thousand men at Camp Chase. Incredibly, other estimates push that number closer to ten thousand and even as high as twenty-five thousand.

Regardless of the exact figure, it was clear that while Camp Chase may have been created for use as a Union training facility, by the height of the Civil War, it was functioning almost exclusively as a prisoner of war camp.

The overcrowding led to less than ideal living conditions. Aside from issues with clean water and food for all the men, some Confederate soldiers arrived at Camp Chase wounded and in need of medical attention. Many never recovered from their injuries. On top of that, the camp proved the perfect breeding ground for diseases, including smallpox, which swept through the camp in 1864, killing many of the prisoners.

Thus, the Camp Chase Confederate Cemetery was created. Originally, deceased Confederate soldiers were interred at Columbus's city cemetery. But with so many bodies to transport and bury, it made more sense to simply bury them at Camp Chase. Unfortunately, during times of war, burying the dead is not something to which a lot of time and effort is given. Many of the

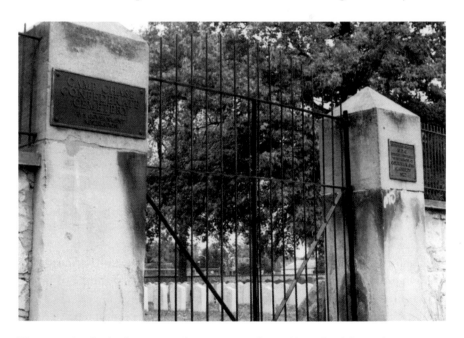

The somewhat foreboding gates at the entrance to Camp Chase Confederate Cemetery. *Author photo.*

Confederate soldiers were hastily buried without permanent grave markers. Some were even placed in unmarked graves.

At the end of the Civil War, Camp Chase was abandoned. All of the buildings were dismantled by 1867, leaving only the cemetery. In 1879, the federal government purchased the site but did little to maintain the property or cemetery. It wasn't until the 1890s that efforts, led by Union veteran William H. Knauss, were undertaken to begin cleaning up the cemetery and identifying those buried within.

How many Confederate soldiers are buried at Camp Chase Confederate Cemetery? It's hard to say with any certainty, but today there is an "official estimate" of 2,122 grave sites inside Camp Chase. That number, however, does not account for those who may be buried in unmarked graves, which pushes the estimate of remains up to 2,168. Further confusing things is that neither number matches the inscription on a monument installed in the cemetery in 1897. The inscription reads: "2260 Confederate Soldiers of the war 1861–1865 buried in this enclosure."

The notion that there are unknown dead buried at Camp Chase Confederate Cemetery may be the reason why it is said to be haunted by a mysterious woman known only as the Lady in Gray. According to legend, she made her first appearance in the early 1900s.

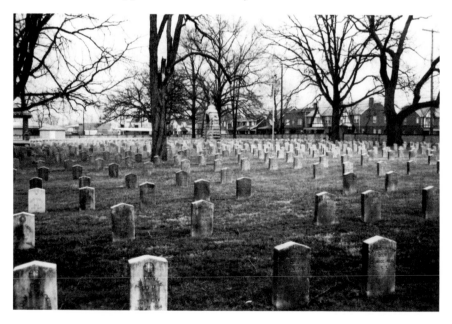

The rows of graves at Camp Chase, between which the Lady in Gray is said to walk. *Author photo.*

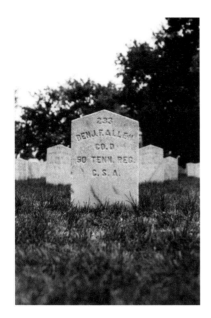

Benjamin Allen's grave, where the Lady in Gray is often seen, sobbing. *Author photo.*

This female ghost acquired her name because she is always seen wearing a gray dress that some describe as a "Civil War–era traveling suit." Her ghost is usually spotted walking among Camp Chase's tombstones but has been known to glide right through the closed cemetery gates. Wherever she's seen, though, she is always sobbing. This led people to surmise that the ghost is mourning a loved one who is interred at the cemetery.

A clue as to who that loved one is may lie in the two graves that the woman's ghost is often seen standing in front of, her head bowed. One of those graves is marked simply "Unknown," while the other belongs to Benjamin F. Allen of the Tennessee Fiftieth Regiment. It has yet to be determined if this woman has any actual connection to the men buried in these graves or is merely paying her respects. Either way, she is clearly overcome with grief, as there have been times when she is not seen and yet her mournful cries can still be heard.

Of course, the Lady in Gray may simply be crying due to the fact that so many men who lost their lives here are in danger of being forgotten.

Ironically, her ghost may be doing her part to ensure that never happens. Today, while Camp Chase has been listed in the National Register of Historic Places since 1973, many people show up with the hopes of possibly catching a glimpse of a ghost dressed in gray. While walking among the graves, they pay their respects to the fallen soldiers. So, perhaps the Lady in Gray is helping to keep the memories of these men alive, if only through her ghostly tears.

HAUNTED FORT AMANDA

Standing on this grassy bluff overlooking the Auglaize River, it's hard to imagine that a bustling, crowded fort once stood here, designed to protect the state of Ohio while nourishing and recharging those whose duty it was to defend the Buckeye State. Today, this field may look empty, but it is filled with the echoes of history. According to legend, sometimes late at night, history can be seen rising up from the grave and wandering through this very field!

On June 1, 1812, President James Madison declared war on Great Britain, including its colonies in the Americas as well as Native American tribes that had become allies of the British. Since the British at the time had control of Canada, the Great Lakes area became a focal point of the war, as those bodies of water were all that separated British troops from U.S. troops.

In Ohio, the body of water in question was Lake Erie. U.S. troops in Ohio were being attacked by Native Americans who had sided with the British and were currently encamped throughout the Northwest Territory. Ohio was already nervous about the possibility of being overrun by British and/or Native American warriors. When General William Hull surrendered Fort Detroit to the British on August 16, 1812, most of what was then known as the Michigan Territory came under British control. American leaders felt it was only a matter of time before the British pushed their way into Ohio. Something had to be done, and it had to be done fast.

The decision was made to create a series of forts running up through Ohio toward Lake Erie. These forts could not only possibly protect Ohio

from an invasion but also provide supplies for U.S. troops heading up to Lake Erie.

In the fall of 1812, General William Harrison gave the order to construct what would become Fort Amanda. He gave that order to Kentucky troops under the command of Lieutenant Colonel Robert Pogue. Wasting no time, Pogue and his men constructed a 160-foot-long stockade. At each of the four corners of the stockade, they erected a two-story blockhouse. Once completed, Pogue named it Fort Amanda, after his daughter, Hannah Amanda Pogue. Fellow Kentuckian Captain Thompson Ward and his company of men were the first to be officially stationed here. They stayed until February 1813, when it was turned over to Ohio militia soldiers under the command of Captain Daniel Hosbrook.

While they were at Fort Amanda, Hosbrook and his men made changes to the fort that almost doubled its size. The stockade was expanded out to make it 160 feet by 320 feet. A fifth additional blockhouse was added as well as some cabins. While the cabins were erected to accommodate the growing number of soldiers who were either passing through on their way north or stationed there, the bulk of the changes were due to the ever-increasing number of supplies Fort Amanda was being asked to store—everything from ammunition and grain to livestock and whiskey.

Shortly after the war ended in February 1815, Fort Amanda was abandoned by the troops. It would eventually be taken over by settlers. Over the years, the stockade and buildings would either be torn down or destroyed. Today, nothing remains of the fort that existed during the War of 1812. The site of the original fort is identified only by a granite monument.

Although not part of the fortifications, one piece of Fort Amanda's history still remains and can be visited: the cemetery. Among those buried here are the remains of seventy-five unidentified soldiers from the War of 1812. These soldiers either died while stationed at Fort Amanda or were severely injured and brought to the fort hospital, where they perished. Either way, the British army's burning of the War Records Office in Washington, D.C., on August 24, 1814, meant that the names of these men are essentially lost forever. This might be why the cemetery comes into play as the location for the first of two ghost stories associated with Fort Amanda.

There are reports of ghostly voices echoing across the cemetery. There are also stories about seeing figures, often reported as "looking like soldiers," walking around both the cemetery and where the fort once stood. It is rumored that these are the spirits of the unknown dead buried in the cemetery, unable to rest until their names are finally revealed.

The second Fort Amanda ghost story is sometimes referred to as the "Legend of the Ghost Cabin." Visitors to the area late at night (which is illegal, by the way; the place closes in the evenings) claim that a small log cabin appears, almost out of thin air. If you stand there and look at it long enough, it will almost seem to take on the appearance of an actual building. However, if you attempt to get close to the cabin, it will vanish as mysteriously as it first appeared.

Obviously, people who believe the Legend of the Ghost Cabin claim that you are seeing a shadow from the land's past and that the cabin was part of the original fort. So far, no one has been able to determine with any certainty if this cabin matches the description of the cabins built on the site. To that end, no one has been able to get inside the cabin before it disappears; what lies beyond the front door remains a mystery. It does, however, raise a rather interesting and terrifying question: If you managed to make it inside the cabin just as it disappeared, would you vanish with it?

3

DOES THE GHOST OF STUART
PIERSON STILL WALK THE TRACKS?

I t is believed that ghosts often linger around the locations where they, in life, met an untimely death. Be it due to confusion or simply just stubbornness to move on, these persistent spirits make up a significant portion of modern ghost lore. Of course, most of these stories contain very few verifiable facts or specifics, which is why many seem to hang around for so long. Simply put, if you can't confirm that a horrific event took place, you can't confirm that it didn't take place, either.

But what about those stories whose tragic event can be confirmed? Does that immediately make the idea of a lingering ghost more plausible? Perhaps. However, as with all ghost stories, the facts must be presented and weighed first. With that, I submit for your review the tragic tale of Stuart Pierson.

Stuart Pierson was born on July 6, 1887, to Newbold and Lydia Pierson. Stuart's father was a successful Cincinnati businessman. By all accounts, Stuart wanted to follow in his father's footsteps. So, it came as a surprise to no one when, in 1905, Stuart was accepted into Gambier's Kenyon College and immediately pledged Delta Kappa Epsilon (DKE), the very same fraternity to which his father had once belonged.

On the evening of October 28, 1905, members of DKE assembled those who had pledged their fraternity in front of a small crowd of past members, which included Stuart's father, Newbold, who had arrived from Cincinnati by train to witness the initiation. It seems weird now, but the idea of initiating pledges in Pierson's time was not uncommon, and if parents were members of the fraternity or sorority, they were often present for part of the initiation rite.

Stuart Pierson's yearbook photo.
Courtesy of Todd James Dean.

At approximately 9:00 p.m., Pierson and the other pledges said their goodbyes and each picked up a small basket they had previously filled with specific items they had been asked to purchase. Then each initiate set off, alone, to the predetermined location they had been told to go to. Stuart Pierson had been instructed to journey down to the railroad trestle that crossed over the Kokosing River. Once there, he was to stand and wait on the trestle until joined by full-fledged members of DKE, who would then take Pierson back to campus to learn if he had been officially accepted into the fraternity. The idea of standing on a train trestle in the middle of the night was designed to frighten and test Pierson, but the fraternity had checked the train schedule, and no trains were scheduled to pass through the area that evening. Stuart Pierson had no way of knowing that, though.

Shortly before 10:00 p.m., the three young men chosen to bring Pierson back ventured down to the railroad trestle. Upon their arrival, they found Pierson's basket sitting near the tracks, but Pierson was nowhere to be found. They called out to him. When they didn't get a response, they came to the conclusion that Pierson had walked across the entire trestle and was now on the other side of the river, out of earshot. The three began to walk across the trestle.

They had walked approximately sixty feet when they stumbled across the mangled, lifeless body of Stuart Pierson lying on the trestle. He had obviously been struck and dragged along the tracks by a train. Unbeknownst to everyone, while the official schedule did not show any trains due on those tracks that evening, unforeseen events had caused several westbound trains to be rerouted through Gambier.

In fact, as the three bent to examine the body, they heard a train whistle in the distance. Fearing that they, too, would be struck by an oncoming train, the three picked up Pierson's body and quickly made for the end of the trestle. Once there, one of the young men, A.E. York, ran to alert Kenyon president William E. Pierce of the terrible accident while the other two remained with Pierson's body.

William Pierce later said that, once he was informed of the accident, his first call was to local doctor Irvin Workman, whom Pierce told to go down to the railroad trestle. Workman did as he was asked. After viewing Pierson's body, talking to the two men guarding the body and examining the scene, Workman asked that Pierson's body be brought to President Pierce's house.

While this was going on, Pierce was breaking the unfortunate news to Newbold Pierson. By the time Stuart's body arrived at the president's house, Newbold was already there. Obviously heartbroken over the loss of his son, Newbold began sobbing about the need to return his son's body home. Seeing as the following day was Sunday, the regular trains would not be running, William Pierce pulled a few strings and was able to have Stuart's body prepared for burial at his house by Dr. Workman and a local undertaker. He was also able to secure a special train that would return the body and Newbold back to Cincinnati. That train left Gambier at approximately 4:00 a.m. on Sunday, October 29. Then and only then did Pierce alert the proper authorities.

As soon as the news hit, it spread across Ohio and the nation, as well. Almost immediately, rumors began circulating that perhaps foul play had been involved. A headline in the October 29 edition of the *Washington Post*, printed mere hours after Pierson's death, read "Train Kills Student: Rumor That He Was Tied to Railroad Tracks Denied." The article did go on to say that when it came to his son's death, Newbold Pierson "told the members of the fraternity that he did not attach any blame to them." But it didn't matter. The newspapers smelled a scandal and were determined to sniff it out.

So was county prosecutor Lot C. Stillwell, who was assigned to the inquest. In what some now look upon as a bit of a vendetta, Stillwell wasted no time in announcing that he felt the case was worthy of a grand jury and that he would be recommending charges be brought against members of DKE. What's more, Stillwell went so far as to accuse President Pierce of tampering with evidence as well as trying to cover the whole thing up by whisking Stuart Pierson's body out of Gambier before it could be fully examined. In fact, Stillwell pointed out, the proper authorities weren't alerted to the fact that there had been a death until after Stuart Pierson's body had departed Gambier.

Stillwell also asked Knox County coroner W.W. Scarbrough to interview witnesses and review evidence to try to determine what exactly happened that night on the train trestle. Scarbrough investigated the case for over a week, and when his findings were officially released, they created a firestorm.

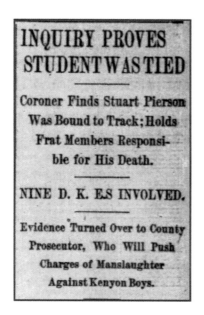

INQUIRY PROVES STUDENT WAS TIED

Coroner Finds Stuart Pierson Was Bound to Track; Holds Frat Members Responsible for His Death.

NINE D. K. E.S INVOLVED.

Evidence Turned Over to County Prosecutor, Who Will Push Charges of Manslaughter Against Kenyon Boys.

The release of the coroner's official report sent the Pierson case in a whole new direction. *From* Chicago Daily Tribune, *Sunday, November 12, 1905.*

Scarbrough announced that he had found sufficient evidence to suggest that Stuart Pierson had been physically tied down to the railroad tracks with rope the night he was killed. The ropes had been so tightly bound that Pierson was unable to free himself when the train approached.

When news of this broke, members of DKE, including former members, as well as President Pierce, denied that any of the fraternity's initiation rites involved tying people up. They contended that Stuart Pierson must have just fallen asleep while lying on the tracks and didn't hear the train coming until it was too late. When interviewed, Stuart's father brought up that the night before the initiation took place, his train into Gambier had been delayed. As a result, Stuart Pierson was awake the entire evening, waiting for his father's train to arrive. This, the father proposed, was the real reason his son never tried to get out of the way of the train: He was simply exhausted and had fallen into a deep sleep.

No evidence of the rope used to bind the young man was ever found, despite newspapers reporting the finding of bloody ropes near the train trestle. There was, however, the basket that Stuart Pierson had been made to bring down to the railroad bridge with him the night of October 28. Wouldn't you know it? One of the items seen inside that basket by several people was, you guessed it, some rope.

Of course, the existence of rope in the basket didn't mean there were plans to use it on Pierson. As a case in point, when asked about the basket, Newbold Pierson admitted knowing about it and about some of the items that should have been inside it. Newbold said his son had purchased safety pins and fig cakes to put in the basket for the initiation. Newbold said he thought all the items were put inside the basket for fun and were never meant to be used. That might have been true, but prosecutors and newspapers also seized on another item Stuart Pierson was allegedly instructed to purchase for the basket: a bottle of chloroform.

Newspapers had a field day with the notion that Pierson might have been chloroformed just prior to his death, despite testimony from fraternity members that having Pierson buy chloroform was a gag to try to frighten him by thinking they might use it on him. No evidence that Pierson was under the influence of chloroform or had even been administered chloroform the night of his death was ever found.

After the inquest formally concluded, prosecutor Stillwell declared that he was ready to turn the case over to the Knox County grand jury so that the guilty person or persons could be brought to justice. In his mind, the evidence, particularly the findings of county coroner Scarbrough, made for an open-and-shut case.

There was just one problem with all the "evidence" put forth by Scarbrough. Namely, it was all acquired after the fact. By the time Scarbrough had been brought in, Stuart Pierson's body was already in Cincinnati and the crime scene had been washed clean. Even though Scarbrough claimed to have examined Pierson's body and found evidence, namely injuries, suggesting he had been tied down, it would be next to impossible to determine when Pierson received those injuries. Finally, and perhaps most important, not a single witness was found who could confirm that anyone had tied Pierson down. For those reasons, the Knox County grand jury refused to try the case, stating that there was insufficient evidence to indict anyone. And with that, the case quickly faded into obscurity.

Lost in all of this was Stuart Pierson himself. Indeed, some would say that if not for the sightings of his ghost over the years, no one today would know his name.

Several years after the accident, someone reported seeing the ghost of a young man standing in the middle of the train trestle crossing over the Kokosing River. More reports started coming in, some claiming that the ghost was walking back and forth across the trestle. Before long, students thought they had a name for the ghost: Stuart Pierson. Since then, dozens of people every year believe they have caught a glimpse of Stuart Pierson's ghost walking near the trestle where he met his untimely death. Years ago, as part of the Rails-to-Trails initiative, the railroad tracks, including those on the section of trestle that crosses the Kokosing River, were pulled up and replaced by asphalt, turning the tracks into one long bike path, the Kokosing Gap Trail. That change, apparently, has done nothing to deter Pierson's ghost from hanging out in the area.

Why does his ghost haunt the area? Legend has it that in the case of sudden, unexpected deaths, there is such a spontaneous release of energy

that it can result in a haunting. If that is true, the case of Stuart Pierson certainly fits the bill. But there seems to be something more at play. The events surrounding what took place on the bridge the night of Pierson's death are, to this day, still shrouded in mystery. Perhaps the ghost of Stuart Pierson is hanging around with the hopes of one day being able to tell the true story of that fateful October night in 1905. Or maybe, just maybe, Stuart Pierson is just doing everything he can to ensure that he's never forgotten.

JAMES THURBER'S HAUNTED HOUSE

Every October, James Thurber's "The Night the Ghost Got In" becomes required reading for students across Ohio. And with good reason: It is a shining example of the wit and writing style of one of Ohio's most beloved authors. Plus, it's about two boys freaking out when they think there's a ghost in their house, so it's perfect for Halloween. But what most people don't realize is that the short story might have been inspired by a night when James Thurber believed he had an actual paranormal encounter.

Born in Columbus in 1894, James Thurber moved into the house at 77 Jefferson Avenue with his family in 1913, when James began his studies at The Ohio State University. They would live there the entire time James was a student at OSU. It was during this time that James and his brother had an encounter that became the inspiration for James's short story "The Night the Ghost Got In." According to the story, which appeared in Thurber's *My Life and Hard Times*, the night the ghost got in was November 17, 1915.

On that night, James had just finished enjoying a late-night bath and was toweling off in the upstairs bathroom when he heard what sounded like "the steps of a man walking rapidly around the dining-room table downstairs." Believing that the footsteps were caused by someone who had just broken into the house, James went and woke up his brother Herman. Together, the two of them crept to the top of the stairs. There, they both heard the footsteps walking around the dining room table. Suddenly, the footsteps broke into a run and started bounding up the stairs toward the boys. Panicked, Herman ran to his bedroom and slammed the door, while James took off for

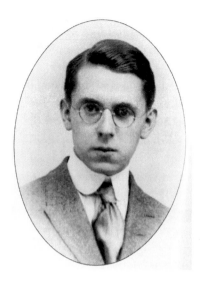

James Thurber in high school. Just a few years after graduating, Thurber would encounter a ghost, or at least write about one. *Courtesy of Thurber House.*

the bathroom and hid behind that door. When he finally peeked out, there was nothing there.

The commotion, of course, had woken up the rest of the family, and it's at this point in Thurber's story that things take a turn for the hilarious worst, including Thurber's grandfather shooting at a police officer. As for the spectral visitor, Thurber simply says that "none of us ever heard the ghost again."

Years after James Thurber's death in 1961, the house at 77 Jefferson Avenue, after major renovations, was officially renamed Thurber House and opened its doors as a museum. The historic house is filled with family memories and memorabilia from the years James lived there with his family. People come from all over the world to see the house that was the focal point of much of *My Life and Hard Times*. Inevitably, some of the guests jokingly ask if the house is really haunted or if Thurber just made the whole thing up. Most are shocked when the docents give them the answer.

After he wrote "The Night the Ghost Got In," James Thurber would go on to say that while he "may have" exaggerated some of the aspects of the story, the part about hearing ghostly footsteps really did happen. What's more, Thurber was convinced that what he had heard was indeed a ghost. Years later, Thurber would remark in a letter that the event was "the only authentic ghost I have ever encountered myself." This despite the fact that he and his brother would often try, unsuccessfully, to re-create the event by standing at the top of the stairs "at midnight" to try to draw out the ghost.

As noted earlier, according to "The Night the Ghost Got In," the events took place on the night of November 17. It is of note that Thurber has things starting "about a quarter past one o'clock in the morning." If that's the case, it might be possible that the ghost actually "got in" on November 18, not November 17. Why would that be such a big deal? On the evening of November 18, 1868, a fire broke out in the Central Ohio Lunatic Asylum in Columbus. The multistoried, multiwinged building was a total loss, and

The house on Jefferson Avenue where Thurber claimed a ghost "got in." *Courtesy of Thurber House.*

seven people lost their lives. Also of note is the fact that part of the property where the asylum once stood is where the house on 77 Jefferson Avenue now stands. Is it possible that what James Thurber heard that night was actually a ghostly reenactment of the asylum fire from almost fifty years earlier?

Still not convinced that James Thurber really heard a ghost? Consider this: In April 1904, jeweler Thomas Tress, thirty-nine years old, was living at 77 Jefferson Avenue with his family. According to the report, Tress returned to his home on Wednesday, April 27, and was talking with his wife before dinner. He then walked over to a dresser and pulled out a revolver, which he pointed at his wife, allegedly in a joking manner. When his wife became frightened, Tress remarked something to the effect that she shouldn't worry because the gun wasn't loaded. At which point, he is said to have turned the gun on himself and fired a single round into his chest, supposedly to prove the gun wasn't loaded. Mortally wounded, Tress staggered to a nearby couch before uttering his last words, which, according to the *Hocking Sentinel*, were,

Illustration from "The Night the Ghost Got In" from *My Life and Hard Times* by James Thurber. *Copyright ©1933 by Rosemary A. Thurber. Reprinted by arrangement with Rosemary A. Thurber and The Barbara Hogenson Agency, Inc. All rights reserved.*

"What a fool I am." Perhaps Thomas Tress needs to be added to the list of potential ghostly suspects lurking around 77 Jefferson Avenue.

It should be pointed out that while James Thurber may be the most well-known resident of 77 Jefferson Avenue to claim to have heard the ghost, he's certainly not the only one. Thurber House for many years has had a writer-in-residence program, which allows a selected writer to live in Thurber House's third-floor apartment for four weeks in order to develop their literary work. The apartment is furnished and even has a journal where authors can let future residents know things like the best places to eat in the area. Flipping through this journal reveals that more than a handful of past writers-in-residence have encountered the ghost of Thurber House. The level of activity ranges from strange noises to the occasional shadowy shape. And, yes, some have even reported hearing footsteps similar to those James Thurber claimed to have heard.

In October 2010, an episode of *Ghost Hunters*, a paranormal reality show featuring the Trans-Atlantic Paranormal Society (TAPS), focused on the Thurber House. TAPS investigators attempted to validate that there was indeed a ghost inside the building. They did experience a few odd things, including a clock behaving oddly several times, but they were unable to determine if the location was officially haunted.

Is there really a ghost at Thurber House? Even with Thurber's own words and the documented loss of life in and around the building, it's hard to say with any degree of certainty. One thing is for sure, though. Whatever James Thurber heard on that fateful night, it inspired him to write "The Night the Ghost Got In." And the literary world is a much better place because of it.

PART II

LEGENDARY CHARACTERS

5

WHO'S JOHNNY?

When it comes to Ohio legends, there is perhaps no more beloved figure than the enigmatic Johnny Appleseed. Why enigmatic? It may come as a shock to many people that a significant number of Ohioans still don't realize that Johnny Appleseed was a real person, or that he walked literally thousands of miles across the Midwest. Oh yeah, and while we're on the subject of Johnny Appleseed, what's the deal with the pot on his head?

The man who would become Johnny Appleseed came into this world as John Chapman on September 26, 1774. He was born to Nathaniel and Elizabeth in Leominster, Massachusetts. Sadly, Johnny's mother died while he was still a boy, and his father later remarried, to a woman named Lucy Cooley. Along with Chapman's children from his first marriage, the couple raised ten children, making for a very crowded Chapman house, indeed.

Some would say that having so many people living under one roof made Johnny yearn for more wide-open spaces. Since not much is known about Johnny's early years, it's hard to say with any certainty if this is true. But it is believed that around 1792, a teenaged Johnny decided to venture out and start exploring, going from Massachusetts to Pennsylvania and eventually ending up in Ohio. Some accounts have Johnny's younger half brother, Nathaniel, accompanying him on the journey. What is known is that Johnny's entire family eventually relocated from Massachusetts to Ohio, possibly on Johnny's recommendation.

Around this time, Johnny began an apprenticeship with an orchardist, a Mr. Crawford. What kind of orchards did Mr. Crawford specialize in? Apple

orchards, of course. Johnny began learning all about apples and orchards, and the rest, as they say, is history.

As the turn of the century approached, pioneers began pushing their way into what was known as the Northwest Territory. In order to entice people west, the Ohio Company of Associates declared that any settler willing to move beyond Marietta, the first (and, at the time, only) settlement in Ohio, and put down a permanent homestead would be given one hundred acres of land. There was a catch, though. In order to prove that the settler's homestead was permanent, they were required to plant fifty apple trees and twenty peach trees within three years. That gave Johnny an idea that would become the model for his very successful business plan.

Johnny followed the trails the pioneers were taking west through Ohio until he reached the end. Then he continued on, pushing farther west than had any of the current settlers. Once he was far enough ahead, he cultivated the soil and essentially laid down the beginnings of an apple orchard. Some say a more accurate description of what Chapman was doing was "starting nurseries," as opposed to creating orchards, because, many times, Chapman would arrive in an area, prepare the soil, add seeds and/or apple saplings and sometimes build fences to protect the land. When the settlers finally caught up to Johnny, he would sell them the orchard and then move farther west to find new fields in which to plant more apple trees. But he would always promise to return to the area from time to time and check on the saplings' progress.

Just like that, the legend of Johnny Appleseed was born.

It is thought that the first nurseries Johnny created were in Pennsylvania. But he quickly moved into the Buckeye State. It is believed that one of the first orchards Chapman planted was located in Ohio, just a few miles from Steubenville. Exactly where Johnny planted many of his nurseries that would eventually turn into orchards is often debated, but it is widely accepted that he is responsible for some in Mansfield, Lima, Perrysburg, Loudonville and Lisbon and several others in Allen and Auglaize Counties.

By the 1830s, Chapman's apple business was so successful that he was the owner or operator of an entire chain of nurseries that stretched across three states—Pennsylvania, Ohio and Indiana. But it wasn't just the nurseries. He also sold apple tree saplings to the pioneers. The going rate was six or seven cents, although Chapman would often accept clothing, food or anything else people had to offer in exchange for the saplings.

It is interesting to note that while Chapman became legendary for his trading of apples and creation of orchards, he wasn't the only one doing it.

In fact, while some of Chapman's competition was spending time developing heartier types of apple trees, Chapman kept using the same old seeds he had been distributing for years. Why was Chapman the one who became such an iconic and endearing figure? From a business perspective, he was smart and stayed one step ahead of everyone else. He did this by pushing ahead of the settlers on the trail, so that when they finally caught up to him, Chapman was already ready and waiting with apples and saplings to trade. He also had an incredible work ethic, which allowed him to plant more orchards than anyone else at the time.

There are those who say it was Chapman's physical presence and demeanor that made him so memorable. Most accounts of Johnny Appleseed's appearance have him dressed in rags and often without shoes. This often leads to the assumption that Chapman was a bit of a vagabond and not the successful businessman he really was. Historians believe the depiction of him dressing in rags is somewhat accurate; it had more to do with his religious faith than anything else.

Chapman was a devoted follower of Emanuel Swedenborg, whose teachings became the basis for the religious movement Swedenborgianism, basically a form of Christianity. One of Swedenborg's teachings was to live and dress simply, and Chapman may have adopted this fashion tip. Regardless, it is well documented that Chapman took every opportunity to spread the word of God as he traveled.

Of course, no conversation about Johnny Appleseed and his attire is complete without mentioning what has become known as "The Pot." One of the most argued-about aspects of Johnny Appleseed is whether or not he walked around wearing a pot on his head. Yes, a pot, complete with a handle sticking out the back. Crazy, right? In fact, most historians, when asked, state that, when Johnny chose to wear a hat, it was usually a traditional cloth hat with a wide brim, similar to those worn by settlers at the time.

Did he ever wear a pot on his head? The jury is still out on this. Some say it's possible, pointing to the fact that whenever Johnny traveled, he traveled very light. He obviously needed to take some of the bare essentials with him, including something to cook in. That's where some historians think the pot came into play—it was nothing more than a universal cooking tool. And, since a hard rain could turn a cloth hat soggy in a flash, what better protection from the rain than a strong, solid pot? In other words, while Johnny Appleseed may indeed have resorted to sporting a pot to keep his head dry in the occasional rainstorm, he almost certainly didn't wear one every day.

Where did such a strange idea come from? Believe it or not, Walt Disney might be to blame.

In 1948, Walt Disney released the full-length animated feature *Melody Time*. The film itself was divided into seven segments, one of which was entitled "The Legend of Johnny Appleseed." The short's first shot is of a book, *American Folklore*. As the book opens up, the narrator begins: "On the pages of American folklore, a legion of mighty men have left the symbols of their greatness: There was Paul Bunyan's ax, John Henry's hammer, Davy Crockett's rifle." As the narrator speaks, the audience is shown the images of an ax, a hammer and a rifle.

Then the book turns to a page marked "Johnny Appleseed," emblazoned with, as the narrator points out, "a tin pot hat, a bag of apple seed, and a holy book." The short then opens on a young, potless Johnny Appleseed, who, after seeing a group of settlers heading west, is visited by his guardian angel, who urges Johnny to travel west. When Johnny is reluctant, the angel gives him some apple seeds and a Bible and places a metal cooking pot on Johnny's head. For the remainder of the short, which covers the rest of Johnny's life, he never takes the pot off his head. When (spoiler alert) Johnny dies at the end and his spirit happily marches off toward heaven, sans pot, his guardian angel promptly snatches up the pot and puts it back on Johnny's head.

Pot or no pot, there's no denying that Chapman managed to turn apples into a lucrative business. At the height of his endeavors, it is estimated that Chapman owned more than twelve hundred acres of land in Ohio alone and many more in Pennsylvania, Indiana and even some in Illinois. The fact that he owned land in four different states shows how far Chapman was able to push into the Northwest Territory. An amazing feat, especially when one considers that he is said to have done the majority of his traveling by foot. There are accounts that Chapman, just prior to his death, claimed to have walked over four thousand miles on the trails through the Northwest Territory.

Johnny Appleseed passed away on March 18, 1845, near Fort Wayne, Indiana, at the home of a friend. He was in the area checking on some of his orchards when it is believed he contracted pneumonia. He was buried in Fort Wayne, although the exact location is still debated. Most believe, though, that his final resting place is atop a small hill in the appropriately named Johnny Appleseed Memorial Park.

Even though he never married, you'd still think a man like Johnny Appleseed left behind one heck of a living legacy upon his passing. Namely,

all those trees. You'd be right to come to that conclusion, were it not for one thing: Prohibition.

In 1920, the United States passed a law making it illegal to produce, sell, transport or import alcoholic beverages. As part of their crackdown on homemade liquor makers, government officials ordered the destruction of many apple orchards, including those that Chapman had started. As a result, many of the trees he planted are no longer in existence. A farm in Nova, Ohio, is said to be the home of the last known apple tree planted by John Chapman.

But the demise of Johnny's trees did nothing to lessen the man's legacy. In fact, as the years wore on, more and more stories were told about Johnny Appleseed, which turned him into something of a national treasure. Today, monuments and memorials to Johnny Appleseed can be found all across the United States. There is, understandably, a high concentration of them in Central Ohio, including a memorial to him in Mansfield's South Park and a monument in Ashland's Brookside Park. In Dexter City, Ohio, there is a sculpture of sorts dedicated to Johnny, reportedly created by using rocks "from along the route" he took back and forth across Ohio. There is even a Johnny

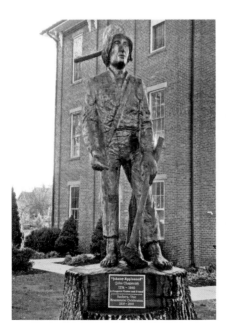

Appleseed Museum on the campus of Urbana University, said to house the largest collection of memorabilia and written information about Johnny in the world.

And let's not forget the annual Johnny Appleseed Festival, held in Lisbon, Ohio. Every September, the village of Lisbon goes "Johnny Crazy" on a weekend filled with events like a parade, a 5K run and even the annual crowning of the Johnny Appleseed Festival Queen and her court.

The memorials keep going up, too. As recently as the summer of 2016, as part of the village of Sunbury's bicentennial celebration, chainsaw artist Jerry Ward was asked to carve something out of a tall ash tree stump on the village square.

This statue of Johnny Appleseed, carved by chainsaw artist Jerry Ward, overlooks Sunbury, Ohio's Village Square. *Author photo.*

Who or what did Ward carve? Johnny Appleseed, of course. The plaque at the base of the statue refers to Johnny as "a frequent visitor and friend," proving that even after all this time, the legend of Johnny Appleseed is still alive and well in Ohio.

Of course, the fact that Ward chose to carve out a big ol' pot for Johnny's head may also be a testament to the power of Disney.

ANDY D-DAY AND THE TWO-HEADED CALF

T ucked away in the corner of Brookville's historic Spitler House lies the remains of someone who, for a time, was the hottest roadside attraction along the entire National Highway: a bull born with four eyes, four horns and two noses.

Incredibly, our story doesn't begin with the aforementioned bull. Rather, it starts with the birth of a calf on the Brookville dairy farm of Wilbur and Nessie Rasor in 1941. But this was no ordinary calf. It was born with two heads. Sadly, the calf died shortly after it was born.

It's unclear how the idea originated—possibly from the fact that the Rasors couldn't stop looking at the two-headed curiosity—but the couple decided to have the animal stuffed and put on display at their family farm. Given that the couple's farm was alongside the National Road, the first multistate highway in the United States, the Rasors' calf soon became one of the biggest roadside attractions for miles around. When national newspapers and *Ripley's Believe It or Not!* came calling, the Rasors found that even when charging a mere ten cents a head, they were able to turn a nice profit.

Fate appeared on the Rasor farm one day in the form of farmer H.W. Douglas of Fort Smith, Arkansas, who was curious to see the family's two-headed calf. As he admired the oddity, Douglas told the Rasors of another, stranger animal, one that he happened to own. The animal in question was a fully grown bull with two complete sets of eyes, two noses and four horns. And, unlike the Rasors' calf, this bull was still very much alive.

Douglas said the bull was born on June 6, 1944, the day of the Allied invasion of Normandy during World War II—a day that would forever become known as D-Day. Naturally, Douglas felt the need to give his new bull, Andy, the last name D-Day.

Douglas told the Rasors that Andy was born "sickly," but after he put Andy under the care of Tulsa veterinarian C.A. Mohr, the bull quickly recovered and began developing normally. What's more, Douglas told the Rasors that Andy was for sale if they were interested in taking a look at him.

To say the Rasors jumped at the chance might be a bit of an understatement. It is said that they immediately made arrangements to follow Douglas back to Arkansas to see Andy. Once they saw the curious bull in person, the Rasors knew they had to own him. They promptly purchased Andy and brought him back to Ohio.

As soon as Andy was in the Buckeye State, Wilbur Rasor set about erecting an outbuilding that could house both Andy D-Day and the two-headed calf. The new exhibit building was officially opened to the public. As the exhibit now offered two curiosities, the Rasors increased the admission fee to twenty-five cents. Additional revenue could be made through the sale of Andy D-Day postcards and crackers, which customers could feed to the bull.

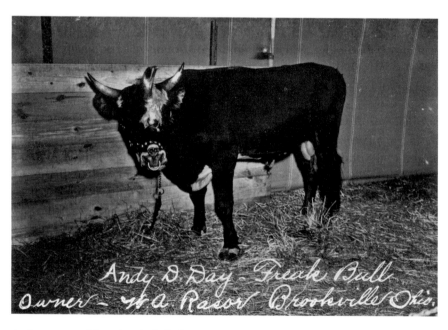

Antique postcard featuring Andy D-Day. *Author's collection.*

The historic Samuel Spitler House in Brookville, where Andy D-Day still resides. *Author photo*.

So many people came to see Andy that the Rasors decided they needed to take things to the next level. Beginning in the late 1940s, the couple took Andy on the road, touring many of the sideshow exhibits in Florida and the southern states.

Andy D-Day passed away in 1956. After his death, the Rasors had Andy's head stuffed and mounted. It's not known what became of the rest of Andy. In fact, while Andy's head stayed in the Rasor family until the mid-1970s, after that, the whereabouts of Andy's head became something of a mystery, too. Some said it had been stolen or taken out of state.

The mystery was finally solved when Andy's head, along with the stuffed remains of the two-headed calf, were discovered on display in the basement of the Spitler House, a historic structure maintained by the Brookville Historical Society. Andy's head and the two-headed calf had been donated to the historical society by the Rasor family and ended up in the basement because they really didn't fit the theme of the other antiques displayed in the home. And, well, a two-headed calf and the giant head of a bull with four eyes might not be something many people would want to see.

But they did want to see it! And they still do. The Spitler House is only open once a month for tours, but it is not uncommon for tour guides to have people walk through the door and make a beeline to the house's basement, part of which has been made to resemble the inside of a barn. There, sitting on the floor, are the stuffed remains of the small, two-headed calf that started it all. Above him, peering down from the wall as if watching over him with all four of his eyes, is the taxidermied head of the massive Andy D-Day.

THE MIGHTY CHIEF LEATHERLIPS

S itting atop a small hill alongside Riverside Drive near the Franklin-Delaware County border is a solitary marker. Hundreds of cars speed past this location, their drivers not knowing they are passing by the final resting place of a mighty Wyandot chief who, many believe, was killed for political reasons by his own people.

To the Wyandot people, he was known as Shayeyaronyah ("same size as blue") or, in later life, Souchaetess ("long gray hair"). But to the Ohio settlers, he was known as Leatherlips. According to legend, the chief acquired the nickname due to the fact that he never broke a promise.

Chief Leatherlips and the Wyandot Indians came to Central Ohio in the late 1700s after relocating from the lands they occupied near Ontario's Georgian Bay. After many years of warring with other tribes, Leatherlips was eager to settle down and live a peaceful existence among his fellow Wyandots. He even went so far as to openly trade with, and form friendships with, settlers in the area—much to the dismay of the other Native American tribes.

That wasn't all the tribes were angry about. By the early 1800s, most of the Native American leaders began to see their people being pushed off their land by settlers in general and the United States specifically. This had to be stopped, but not a single Native American tribe was powerful enough to stand up to the U.S. military.

The Shawnee leader, Tecumseh, had an idea. He would get all the individual tribes to come together under one unifying cause: take back

their homeland. Perhaps as one group they would have enough numbers to be successful.

One by one, leaders from Native American tribes pledged their men in support of Tecumseh. As more joined, Tecumseh reached out to the Wyandot leader, Leatherlips, and asked him to join as well.

There was just one problem. In August 1795, Leatherlips had signed the Treaty of Greenville. The treaty, among other things, effectively ended the Northwest Indian War. More important, those Native Americans who signed it had pledged to never again take up arms against the United States. Leatherlips felt bound to the pledge he had signed.

So, while many more Native American tribes joined Tecumseh, Leatherlips refused, saying he could not break his oath. In 1810, in a last-ditch effort to get Leatherlips to change his mind, Tecumseh threatened the Wyandot leader with death if he did not join. When Leatherlips refused yet again, a Native American council was held. It was agreed to charge Leatherlips with "witchcraft." The penalty for such a crime was death. Shortly after the council made its announcement, a small group of at least four Wyandots was dispatched to Ohio to find Leatherlips and carry out his execution.

While the official charge against Leatherlips was witchcraft, it was widely understood and accepted that this was nothing more than a political move by Tecumseh to punish someone who refused to take up arms with him. That being said, most believed Leatherlips would flee or, at the very least, try to fight the charges. He did neither.

Instead, when confronted by the group charged with executing him, Leatherlips calmly asked for a council meeting so he could hear the charges brought against him. This was agreed to; it is said that the meeting lasted several hours. At the end of it, Leatherlips still refused to take up arms against the United States; as a result, his execution was upheld.

After the meeting broke up, Leatherlips walked through his camp and sat down for dinner. When he was finished, he retired to his dwelling and prepared himself for death, dressing in his finest clothes. Unbeknown to Leatherlips, several area settlers were, at this time, attempting to convince the executioners not to go through with their assignment. It is said that one settler in particular, Benjamin Sells, even went so far as to bribe the executioners by offering up his own horse in exchange for Leatherlips's life. Sells's requests fell on deaf ears.

When the time for the execution arrived, Leatherlips walked from his dwelling and began to chant in his native tongue, the executioners following behind. Before long, Leatherlips reached a shallow grave,

beside which he knelt and continued chanting. Without warning, one of the executioners drew a tomahawk and brought it down swiftly on the head of Leatherlips, who immediately collapsed. After several more blows, Leatherlips was officially declared dead and his body placed in the shallow grave. After the group of executioners had filled the grave back in, they left Leatherlips's encampment.

In 1889, the Wyandot Club of Columbus placed a monument on a small hill overlooking the Scioto River. The monument was described as "Scotch granite with a Quincy granite base and stands on the spot where he [Leatherlips] was executed and buried." But does the stone really mark the spot?

For more than thirty years after that monument was erected, Ohio newspapers were carrying stories about the "hunt" for the "grave of old Leatherlips." There were also multiple reports of a "boulder bearing the inscription 'Leatherlips'" being "found by highway workers several years ago near the Scioto river at the Franklin-Delaware county line." Most believed that this "marked the burial place" of Leatherlips. It is never made clear,

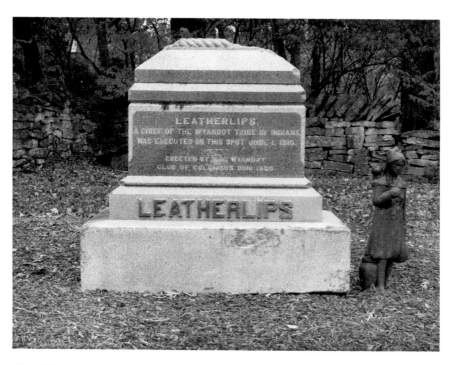

Along Riverside Drive is a solitary grave that marks the spot where the Wyandot chief Leatherlips was executed. *Author photo.*

though, if this stone was the impetus in the Wyandot Club's monument being placed where it was or if this is a stone found in a new location. Regardless, newspapers claimed that the site where this boulder had been found was excavated but did not "reveal any traces of a grave." Once again, it is never discussed whether the excavation took place near where the monument stood or at another location.

Further confusing things is the 1965 book *This Is Ohio* by Grace Goulder. According to Goulder, the execution of Leatherlips was carried out near the entrance to what are now known as the Olentangy Indian Caverns and he was buried near the caverns. This seems to conflict with multiple nineteenth-century newspapers describing the event. They state that the executioners followed the banks of the Scioto River to "where the tragedy was enacted." For reference, the caverns are roughly four miles from the Scioto River. The Scioto Club's monument almost overlooks the Scioto and is but a few hundred yards away from it.

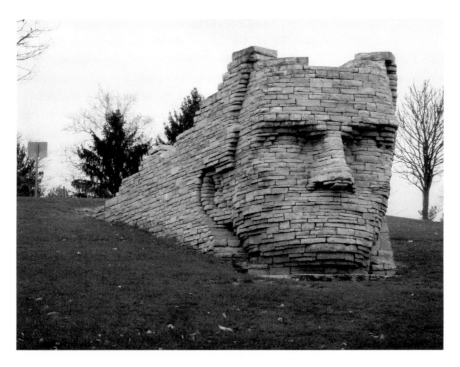

The Chief Leatherlips Monument is said to have been erected near or over the Wyandot chief's last hunting camp. *Author photo.*

But even if this stone marker isn't in the exact spot of the execution, it still draws people from all over to come and pay their respects to the fallen Wyandot chief. As Leatherlips called the entire area home, in 1990, the Dublin Arts Council commissioned artist Ralph Helmick to create a twelve-foot-high statue of Leatherlips's head. Using limestone slabs that were mortared together, Helmick created an amazing sculpture of the Wyandot chief's head, which looks out toward the peaceful waters of the Scioto River. It is a fitting tribute to a Native American leader who simply wanted to live in peace, only to be betrayed by some of the very men he was trying to protect.

ANNIE OAKLEY, LITTLE SURE SHOT

One of the most iconic figures associated with the Wild West is that of Annie Oakley: a petite, young girl in a long dress, firing off rounds from her rifle and doing amazing trick shots. It may come as a surprise to many that such a legendary character actually got her start on a small farm in Ohio.

Annie's parents, Susan and Jacob, were Quakers of English descent who had relocated from Pennsylvania to a Darke County, Ohio farmhouse around 1855. Born Phoebe Ann Moses (sometimes listed as "Mosey") on August 13, 1860, Annie was the fifth child of the Moses family, making for a lot of mouths to feed. Jacob was forced to take a job at a mill many miles away in order to help make ends meet.

In the winter of 1865, a blizzard of epic proportions swept across the Midwest. Jacob Moses was caught in it while returning home from the mill. When he finally reached the house, his arms and legs were almost frozen solid and he couldn't even speak. He would linger for several months, but Jacob Moses never recovered from that horrific night in the snow. He died in March 1866, leaving his family all but destitute.

Susan Moses did all she could to try and survive, but she faced an uphill battle trying to go it alone with so many children. Having nowhere else to turn, in March 1870, Susan was forced to admit nine-year-old Annie to the Darke County Infirmary, which also functioned as the "poorhouse." Shortly after arriving at the infirmary, Annie was "bound out" to a local family. This was a common practice at the time. People from the poorhouse

were sent to live with families to work in exchange for room and board and, in the case of younger children, schooling. In Annie's case, she was to receive fifty cents a week and schooling in return for doing chores and helping to care for the couple's infant son. It sounded like a fair deal for Annie, but it turned into a nightmare.

Not only did Annie not receive any schooling (and, according to some accounts, pay), but she was also subjected to physical and emotional abuse so intense that, for the rest of her life, Annie would not refer to the couple by name. Instead, she chose to call them simply "the wolves."

Annie tried her best to survive with the wolves, but in 1872, at the age of twelve, she had enough. Making her way to the local train station, Annie hopped aboard a railroad car and made her way back to her family in Darke County. When Annie arrived home, she found that nothing had changed; her mother was still poor and unable to support Annie. Reluctantly, Annie made her way back to the poorhouse. Still, the fact that Annie had taken it upon herself to escape the bad situation with "the wolves" was, according to some historians, representative of her "grab hold of every opportunity" approach to life, which she would exhibit later in life.

Annie remained at the poorhouse until 1875, when she once again returned home. Other than her mother remarrying, not much had changed. The family still had no means of supporting Annie. This time, though, Annie was determined to find a way to support not only herself, but her family, as well. She was going to do whatever it took to not go back to the poorhouse.

Annie took Jacob Moses's old gun and taught herself to shoot. She got good at it, too. Fast. Before long, Annie's shooting skills made her a natural at hunting, and she and her family were eating better than they had in a long time. Then, Annie got a brilliant idea: She'd use her hunting skills to earn money by selling what she shot to local grocers. She started selling game to shopkeepers and grocers in the Greenville, Ohio area. When Annie discovered that they were, in turn, selling it to hotels in the Cincinnati area, she decided to cut out the middleman and sell game to local hotels, as well. As a testament to her shooting skills, Annie was so successful with her business that she was able to pay off the mortgage on her mother's house while still a teenager. Word quickly began to spread of a teenage marksman who actually happened to be a markswoman. Needless to say, that news caused quite a commotion, as women were not supposed to be going around shooting guns.

That's not to say men weren't. Far from it. In the 1870s, it was important for a man to know how to shoot. It was not uncommon for men to challenge

each other to shooting contests. This gave rise to traveling shows featuring "sharpshooters" who would often challenge members of the audience, almost always men, to see who was better. The sharpshooters never lost, but that didn't stop men from going to these shows and accepting the challenge to try to outshoot these champions.

One such sharpshooter was a man named Frank Butler, part of the shooting act Baughman & Butler. Butler's act included the claim that he could beat any shooter, any time, any place. One fall evening in 1875, Butler was in Cincinnati talking with some locals when it was brought to his attention that there was someone in the area who many thought could beat him. Butler initially laughed at the idea, but when a $100 bet was offered, he became interested. He accepted the challenge to beat this local sharpshooter.

Imagine Butler's surprise when the mysterious sharpshooter turned out to be a teenage girl! There are some discrepancies about what exactly happened on that historic day, but most historians agree that Annie and Frank matched each other shot for shot for twenty-four rounds...and then Frank missed, losing the bet.

People agree that something else happened that day: Frank Butler was smitten by Annie. They were married shortly afterward, making them perhaps the only couple to fall in love over a shooting match.

After they were married, Annie left Ohio and began traveling with her husband, who now had a new shooting partner, John Graham. Annie herself did not do any shooting during the performances. That is, until one night in Springfield, Ohio, when Graham fell ill just before the performance. Frank asked Annie if she would be his assistant, which involved holding the targets or tossing them into the air for him to shoot. Annie agreed. For whatever reason, Frank's aim was off that night and he couldn't hit the targets. According to legend, among the boos and hisses coming from the audience, someone yelled out something to the effect that Frank should let the young lady have a go at shooting the targets—she couldn't do much worse.

Frank is said to have handed the gun to Annie, who almost immediately began firing. She didn't miss a single target. The legend of Annie Oakley was born. The origin of the name "Oakley" and the reason Annie chose it is still being debated today. The most popular answer is that Annie borrowed the name from her paternal grandmother. Other explanations run the gamut, from "Oakley" being the name of a street where she once resided, to it being the name of a man who paid her train fare when she was penniless.

Regardless, after that night in Springfield, there was a new sharpshooting duo in town: Butler and Oakley. The team traveled across the country, playing everything from circus sideshows to vaudeville theaters. Annie even took to making her own costumes and made the decision to always be clothed in full-length dresses. The striking image of a petite young girl in a dress, coupled with her holding a rifle, raised many an eyebrow. It also caused more than a few young men's hearts to flutter.

Annie's act was something to behold. She would often begin with a single target, such as a glass ball filled with feathers or some other material that would make a big visual splash when she shot it. Then she would continue to add more targets, with Frank often tossing multiple targets into the air at once. Annie would calmly shoot them all, sometimes switching guns and shooting the targets before a single one hit the floor. She never missed. Well, that's not entirely true. Sometimes she would miss on purpose, just to get the audience riled up.

As her performance progressed, she would often take to turning playing cards on their side and then shooting them in half. She was also known to shoot dimes tossed into the air and, in special performances, cigarettes and cigars from people's mouths.

The more Annie and Frank toured, the more people came out in droves to see this new female sensation who could shoot as well as any man, or better. Annie became so popular that Frank, ever the businessman (and admiring husband), flipped their names on the marquees and posters, making Annie the main attraction.

Annie's reputation eventually found its way to Buffalo Bill Cody, who was making a name for himself with his immensely popular Wild West show—a theatrical presentation that included everything from live animals and sharpshooter exhibitions to reenactments of "Wild West battles" between settlers and Native Americans.

Reluctant to sign Annie at first, Buffalo Bill was eventually persuaded by his manager, and Annie and Frank began to tour the world with the Wild West show, entertaining famous people and heads of state, including England's Queen Victoria, King Umberto I of Italy, President Marie Francois Sadi Carnot of France and Germany's kaiser, Wilhelm II. On request, Annie shot the ashes off Wilhelm's cigarette while it was in his mouth.

But perhaps one of the most memorable, if not storied, encounters between Annie and a member of the audience took place when she gave a performance to a crowd that included a group of Sioux Indians. Among this group of Native Americans was the famed leader Sitting Bull. He was

so impressed by Annie's abilities that, after the show, he allegedly asked if he could adopt Annie. He also gave her a nickname that would stay with her the rest of her life: Watanya Cicilla, "Little Sure Shot."

Annie continued touring with the Wild West show until the fall of 1887, when she abruptly left, allegedly over disagreements with Bill Cody. During the course of the next decade or so, Annie and Frank toured by themselves, occasionally signing up for a one-off tour with Buffalo Bill's Wild West show. Each year, however, it seemed that fewer and fewer people were coming out to see Annie. It wasn't that her show wasn't as captivating as it had been. Far from it. It just seemed that people had moved on to bigger things.

Still, at the dawn of the twentieth century, Annie pressed on, more determined than ever to mount a comeback. Not even her suffering a severe spinal injury in a train accident in the fall of 1901 seemed to slow her down. Unfortunately, Annie was about to run into something bigger than herself: bad press.

On August 11, 1903, Chicago-area newspapers ran a story with the scandalous headline "Annie Oakley Arrested." The article went on to say that Annie Oakley, "famed woman rifle shot," had been arrested in Chicago two days earlier and charged with "stealing the trousers of a negro in order to get money with which to buy cocaine." The story was picked up and spread quickly across the United States. There was only one problem: they had the wrong Annie Oakley.

It turns out that the woman who was arrested was a burlesque dancer who either adopted "Annie Oakley" as her stage name or else lied about who she was. Either way, some simple fact-checking probably would have revealed the truth. As for the real Annie Oakley, she felt that her name and image had been tarnished, so much so that she turned around and sued all fifty-five newspapers that had run the story, making it one of the largest libel suits at the time. When all was said and done, Annie won judgments against fifty-four of the fifty-five newspapers. Ironically, since the cases had dragged on for over six years and Oakley often had to travel for the trials, she ended up losing money with her suits.

When she turned fifty, Annie returned to the Wild West show, but by this time, there wasn't much interest in sharpshooters, even someone as famous as the legendary Annie Oakley. She officially retired in 1913 but would occasionally show up for an impromptu demonstration or, more often than not, to speak out and encourage women to learn how to shoot, if not for sport, then for protection.

At the age of sixty-six, people noticed a marked decrease in Annie's health. Some say it was the result of a bad car accident she had been involved in back in 1922. Others actually whispered that perhaps she had gotten lead poisoning after all those years of handling the lead shot she used in her performances. Regardless, Annie herself seemed to understand that her performing days were long over. She quietly melted down all the medals she had acquired over the years and donated the money to charity.

Annie Oakley passed away on November 3, 1926. Less than three weeks later, Annie's beloved husband, Frank, joined her in death. According to her wishes, Annie's body was cremated. There is a popular legend that says the urn containing Oakley's ashes was actually placed inside Frank Butler's coffin before it was interred at Brock Cemetery, just outside Greenville, Ohio, not far from where Annie first taught herself to shoot.

The years have done nothing but further cement Annie Oakley's name in history. If nothing else, she was a trendsetter who was years ahead of her time. She made a name for herself in a male-dominated profession and

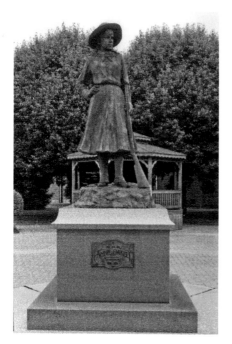
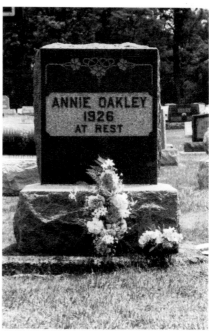

Left: A statue of Annie Oakley stands guard over the entrance to the Annie Oakley Memorial Plaza in Greenville, Ohio. *Author photo*.

Right: Some say this isn't the final resting place of Annie Oakley. Her cremains were placed inside her husband's casket before burial next to her. *Author photo*.

did it with grace. Her marksmanship has been widely recognized, too, and she has been posthumously inducted into such illustrious institutions as the Ohio Women's Hall of Fame, the Trapshooting Hall of Fame, the National Women's Hall of Fame and even the National Cowgirl Hall of Fame. She had her own museum and research center, the National Annie Oakley Center, in Greenville, Ohio.

Not bad for a small-town farm girl from Ohio, huh?

9

THE MANY GRAVES OF WILLIAM QUANTRILL

When it comes to Ohio's involvement in the Civil War, there's hardly a more polarizing figure than William Quantrill. While most history books talk of him and his deeds in extremely unflattering terms, to others, he was a true war hero. Who William Quantrill really was and whether or not his acts were honorable is open to debate, but one cannot argue about the weirdness surrounding what happened to William Quantrill after his death—legend says William Quantrill's body, or pieces of it, are buried in at least three separate graves across the United States.

William Clarke Quantrill was born on July 31, 1837, to parents Thomas and Caroline in Canal Dover (now simply Dover), Ohio. The oldest of eight children, little is known about Quantrill's early years other than that he was incredibly intelligent. When his father passed away in December 1854, the family was forced to turn the home into a boardinghouse in an attempt to make ends meet.

The following year, William left Ohio to seek work. He tried various jobs, including schoolteacher, in different states, but he was unsuccessful. He eventually returned home to Canal Dover several years later, but not before adopting a strong proslavery stance that he had acquired during his travels.

When the Civil War broke out in 1861, Quantrill enlisted in the Confederate army. Officially, he was a captain, but Quantrill had trouble following the rules. He decided to form his own band of guerrillas,

who would make their bones raiding Union towns. In instances where they outnumbered groups of Union soldiers, they would attack. They didn't follow the traditional rules of engagement, though. Rather than typical skirmishes and battles, in which troops lined up and started firing, Quantrill and his men would plan carefully orchestrated missions: the men would launch a surprise attack and get in and out before anyone knew what hit them.

It didn't take long for Quantrill to realize he was good at this sort of guerrilla warfare. Others started noticing, too, and before long his group had a nickname: Quantrill's Raiders. Their numbers would soon swell to several hundred men, including outlaw Jesse James and his older brother, Frank. As for the Union army, while it was aware of Quantrill's Raiders, it considered him nothing more than a nuisance. That is, until Quantrill set his sights on Lawrence, Kansas.

Even before the start of the Civil War, Lawrence was considered a stronghold for the antislavery establishment. Now, with the war going full-force, Lawrence was seen as a location from which pro-Union forces could march into Missouri. Clearly, this was a spot from which Quantrill felt he could deliver a strong message to the Union troops.

In the hours before dawn on August 21, 1863, William Quantrill and as many as 450 men attacked the town of Lawrence, Kansas. Almost everyone in the town was still asleep, so Quantrill's Raiders were met with little, if any, resistance. In fact, once people realized they were under attack from the raiders, most chose to stay inside to try and wait things out. Usually, Quantrill would have his men attack, overpower the enemy, grab everything of value and leave. This time would be different, though.

In what could only be described as a bloodbath, Quantrill ordered his men to shoot and kill any male "old enough to carry a rifle." This included teenage boys as well as men well into their eighties. By all accounts, women and young children were spared, but everyone else was fair game, even if they were unarmed and showed no resistance, which was said to have been most of the town. In fact, the only Union soldiers present in the town were seventeen teenage recruits, all of whom were unarmed.

Several hours later, after the town had been completely looted, Quantrill and his men set fire to all of the buildings and left. When the smoke finally cleared, an estimated 150 people had been killed, all but 17 of whom—the teenage recruits—were civilians.

When news of the attack hit the newspapers—many of which called it the "Lawrence Massacre"—Quantrill found himself a wanted man.

His actions resulted in public outcry, forcing Union leaders to turn their focus on apprehending Quantrill. Simply put, the hunter had become the hunted.

The Union forces started stealing plays from Quantrill's own guerrilla warfare playbook. Suddenly, Quantrill's Raiders found themselves being pursued at every turn and even being ambushed. Quantrill decided he needed to retreat and join with a larger Confederate force, if only until the heat was off.

Quantrill might have thought he was in the clear when he and his men managed to cross into Kentucky in early January 1865. But once there, everyone from Union troops to private hired guns continued to pursue Quantrill and his men, capturing or killing members at every turn. Quantrill himself always seemed to elude capture, although his once large group of followers was dwindling quickly.

Quantrill's luck began to run out in April 1865, when a young Union captain by the name of Ed Terrill, along with a group of approximately twenty-five men, decided to continually attack the raiders. At every encounter, Quantrill would somehow slip away, but Terrill's pursuit was relentless.

On the morning of April 10, 1865, Quantrill and his men were hiding in an old barn on a farm belonging to James Wakefield near Shelbyville, Kentucky, when Terrill and his men attacked. Quantrill ran for his horse but was shot before he could reach it. In fact, his wounds were so severe that he was almost completely paralyzed.

After his capture, Terrill had Quantrill sent to a military hospital in Louisville, Kentucky, where he succumbed to his injuries a month later, on June 6, 1865. He was buried in a local cemetery, now known as St. Mary's Catholic Cemetery, chosen because of its proximity to the hospital where Quantrill died. Some said that the grave was unmarked, at Quantrill's request. Regardless, here Quantrill's remains would remain, intact, for twenty-two years. Then, a very strange event took place, one shrouded in mystery to this day.

As the story goes, newspaperman William W. "W.W." Scott, who had been a schoolmate of William Quantrill, was asked by Quantrill's mother, Caroline, to travel to Kentucky in order to identify her son's remains so that they could be reinterred closer to his birthplace of Dover, Ohio. It is said that Scott made not one, but two trips to Kentucky. On the first trip, he apparently located Quantrill's grave. Scott returned a second time to dig up the remains. He allegedly brought Quantrill's mother along, too, so that she could help identify the remains.

It's unclear what procedure, if any, Scott followed in order to dig up the remains. Some say he did it in secret; others say it was done with permission from the cemetery staff and in broad daylight. Those who adhere to the latter version of the tale list May 18, 1888, as the date Scott dug Quantrill up.

Scott would later say that once he dug up the grave, he found that most of Quantrill's body had disintegrated to the point that only a few larger bones, some hair and the skull remained. Scott removed what he could from the grave, placed it all inside a box and presented it to Quantrill's mother, who identified the skull as belonging to her son (a chipped tooth mirrored an injury William Quantrill had received in his younger days).

Just how much of Quantrill really ended up in the box is still debated. It is clear, though, that a lot of him was left behind. For that reason, William Quantrill's grave at St. Mary's Catholic Cemetery still bears a headstone.

With William Quantrill's remains finally back in Ohio, one might think the story ends here. Not even close. For reasons that aren't really clear, Quantrill's mother didn't immediately rebury her son's remains. Some say it was because the local cemetery refused to allow such a notorious figure to be buried there. Others say the cemetery would allow the reburial, but only in an unmarked grave. Eventually, though, Caroline Quantrill is said to have laid her son to rest. But did she?

It would be another one hundred years, in 1982, when a tombstone for William was erected on the Quantrill family plot in Dover's Fourth Street Cemetery. Of course, that could simply mean that Caroline Quantrill gave in to the cemetery and allowed her son to be buried, or reburied, in an unmarked grave. Then people started saying that Quantrill was actually buried somewhere else in Dover.

Local newspapers made it even harder to determine exactly what happened. In a 1964 article discussing whether or not Caroline Quantrill buried her son in Fourth Street Cemetery, Dover's newspaper, the *Daily Reporter*, stated that "there is no evidence to support any rumor that the burial was not completed as planned. Neither is there any evidence that his bones have ever been moved from the family plot in the E. 4th St. Cemetery." Then there's the 1971 article in the *Daily Reporter* claiming that "Scott brought Quantrill's remains to Dover in a zinc box" and then "buried them in secret at a spot designated by Quantrill's mother." Perhaps strangest of all is the 1922 report in New Philadelphia's *Daily Times* that had Quantrill's relatives denying "Quantrill's body was removed by his mother to Dover, and buried in a cemetery by the side of his father."

Whether or not Scott buried a box at the Fourth Street Cemetery—or anywhere else, for that matter—is something of a moot point today. From what we know now, even if there was a box, pieces of William Quantrill were missing from it, including his skull.

We know this to be true because friends and family members of Scott admitted to seeing Quantrill's skull, bones and hair in a box inside the Scott residence. At first, it appeared this was only for safekeeping while a final resting place could be found. But as time went by, the box stayed aboveground and would sometimes be stored at Scott's newspaper office.

At some point, Scott even began attempting to sell Quantrill's skull to historical societies and private collectors. It is said that Scott offered to sell the skull to the Kansas Historical Society in Topeka for thirty pieces of silver but was turned down. Several of Quantrill's other bones and a clump of his hair did eventually make their way to the Kansas Historical Society.

After Scott passed away, his family continued trying to get someone to buy Quantrill's skull. In 1902, Scott's son gave up trying to sell the skull and simply donated it to a local boys' group, the D.J.S. Club, which allegedly used it for its initiation ceremonies. It was the D.J.S. Club that gave the skull the nickname "Jake." D.J.S. would only be in existence for a few years, though, and by 1910, Quantrill's skull had moved on to the Alpha Pi fraternity house, where, once again, it became part of initiation rites. The fraternity continued to use it until around 1942, when Alpha Pi disbanded. At that point, Quantrill's skull disappeared. It wouldn't officially be seen again until thirty years later, when a former fraternity member showed up at the Dover Historical Society and donated the skull.

In the late 1980s, a movement to bring all the known remains of William Quantrill together in one place was started by the Missouri division of the Sons of Confederate Veterans. Their idea was to reunite as much of Quantrill that was still aboveground and bury it all together in the Higginsville, Missouri Confederate cemetery. It took several years of negotiating, but the Kansas Historical Society finally agreed to turn over what remains it had to the Sons of Confederate Veterans. The Dover Historical Society, however, wasn't budging when it came to the skull. It wanted the skull to remain in Dover, where Quantrill's mother wanted it all along. The historical society did, however, offer to accept all of the other gathered remains and bury them with the skull in Dover. The Sons of Confederate Veterans refused the offer, stating that it wouldn't be appropriate for Quantrill to have a Northern resting place. Instead, on Saturday, October 24, 1992, approximately six hundred people attended a ceremony, complete with a Confederate-costumed honor

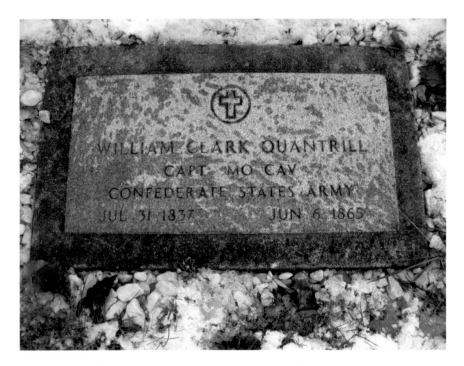

Here, in Dover's Fourth Street Cemetery, lies the body of William Clarke Quantrill—at least parts of him. *Author photo.*

guard firing muzzle-loading rifles, at Higginsville's Confederate Cemetery. Quantrill's remains, sans skull, were laid to rest in a coffin draped with a Confederate flag. Descendants of Quantrill's Raiders led the procession to the grave site.

A few days later, on October 30, a ceremony was held at Dover's Fourth Street Cemetery and a small casket containing Quantrill's skull was laid to rest in the family plot. According to legend, the casket was placed in a shallow grave only three feet down, just in case William Scott really had buried something there all those years ago.

For those keeping score at home, William Quantrill's mortal remains are officially known to exist in three separate cemeteries in three different states:

The original unmarked grave in Kentucky (now marked)
The Confederate cemetery in Missouri
The Fourth Street Cemetery in Ohio

For safekeeping, the wax head of William Quantrill is stored in this refrigerator.
Author photo, with permission from Dover Historical Society.

In a weird postscript to this tale, at some point prior to Quantrill's skull being reburied, the Dover Historical Society asked a Kent State University professor to attempt to create a wax re-creation of Quantrill's face. Using the skull as a guide, the professor was able to create a full-size version of William Quantrill's head, complete with hair, eyebrows, a mustache and even piercing blue eyes. It was put on display with all the other artifacts and historical memorabilia housed in the carriage house of the Reeves Home and Museum in Dover. Unfortunately, the wax head didn't take too kindly to Ohio weather, and the wax began to crack and, during summer months, "sweat a little." So it was taken off display and moved to a cooler environment. It's currently being stored in a 1929 GE refrigerator inside the carriage house.

PART III

LEGENDARY VILLAINS

NEVER ACCEPT A BUGGY RIDE
FROM ALBERT FRANTZ

S hortly after 6:00 p.m. on the evening of August 27, 1896, twenty-three-year-old Bessie Little told the owner of the Dayton boardinghouse where she was living that she was going out on a buggy ride with her boyfriend, Albert J. Frantz, a man almost three years younger than herself. She would never return. What followed was one of the most sensational and scandalous trials the area had ever seen, complete with allegations of unwed "relations," evidence tampering and even a severed head presented to the jury as evidence.

On September 2, almost a week after Bessie Little was reported missing, a man by the name of E.L. Harper was cooling off in the Stillwater River, not far from the Ridge Avenue bridge. As he swam, he noticed what he originally took for a loose shoe floating in the water. Going over to investigate, Harper was horrified to find the shoe was actually still attached to the badly decomposed body of a young woman. Authorities were able to identify the body as that of Bessie Little. At first, her death was believed to have been an unfortunate drowning accident or a suicide. As a result, the body was laid to rest.

Something wasn't adding up, though. Why had Bessie Little chosen to take her own life? And if it was an accidental drowning, how did she end up in the water in the first place? Under pressure to find the answers, authorities dug up Little's body and examined it a second time. Upon closer inspection, a bullet hole was found just below Little's right ear. It was then that authorities made the decision to remove Little's skull so it could be examined

further. Examination of the skull revealed fragments from two bullets inside, leading police to suspect foul play and begin looking for suspects. Albert Frantz's name came up almost immediately, as he had once been found in a "compromising position" with Little and had been forbidden from seeing her unless he proposed marriage. It came to light that the last time Little was seen alive, she had been going out to meet Albert Frantz. He was brought in for questioning.

During questioning, police discovered that on August 28, the night after Bessie Little went missing, a fire destroyed the Frantz stable and all its contents, including the horse and buggy the pair were alleged to have been riding in the night Bessie Little disappeared. Neighbors claimed to have seen Frantz standing near the stable as it burned, apparently unconcerned about putting it out or attempting to rescue any of its contents, including his horse. It would later be shown that the fire had been started directly underneath the buggy, further suggesting that someone had lit the fire with the intent of destroying the buggy. Shortly after hearing this, police arrested Frantz on suspicion of murder.

For the most part, Frantz denied everything. He did admit to taking his horse and buggy out for a ride the night Bessie Little disappeared, but he claimed he was alone and never saw Bessie that evening. Then, two teenage boys fishing on the bridge spanning Stillwater River stumbled across a small pool of blood. Lying inside the blood was a hair comb. A trail of blood drops led to a large bloodstain along the bridge's railing. Next to that was a second hair comb. Both combs would later be identified as belonging to Bessie Little. Police now believed they had found the murder site.

Once word got out that Bessie Little's murder site had been located, the road to the bridge became congested with traffic as people flocked to the area. Local newspapers went so far as to report that "thousands" of people visited the bridge in the morbid hopes of catching a glimpse of bloody evidence of the crime.

On September 10, Albert Frantz was officially charged with murder in the first degree. Prosecutors believed they had enough evidence, especially since, under questioning, Frantz admitted to being on the bridge with Bessie that night, although he claimed that she had committed suicide by shooting herself twice. Frantz said he didn't know of Little's plan and was shocked when she suddenly pulled the gun out. He did admit to panicking and throwing both the gun as well as Bessie Little's body into the Stillwater River before leaving the bridge. Frantz claimed he was innocent and only acted the way he did because he believed he would be blamed for the shooting.

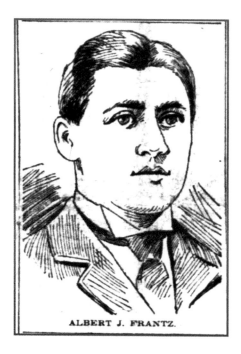

ALBERT J. FRANTZ.

Left: This illustration of Albert Frantz accompanied news stories of his trial. *From the* Cincinnati Enquirer, *Monday, September 7, 1896.*

Below: As this front-page headline attests, Albert Frantz never fully confessed to the crime. *From the* Daily Herald, *Friday, September 11, 1896.*

CHARGE OF MURDER.

Albert Frantz Held Accountable for Bessie Little's Death.

A PARTIAL CONFESSION MADE.

He Claims That the Girl Killed Herself on the Bridge and That He Threw Her Body and the Revolver Into the River.

When Albert Frantz was brought before Judge Dale to enter his plea, the area around the court was jammed with people trying to get inside the building. They were spilling off the sidewalk and out into the streets, yelling and screaming and generally creating a party-like atmosphere. As for Frantz, he stood calmly before the judge and entered a plea of "not guilty." He was ordered held without bail pending trial. As he left the courtroom, the crowds outside only continued to grow.

The number of people swarming around the bridge where Bessie Little died also continued to rise. Not only was there a murder site to visit, but with Frantz's admission to throwing the gun into the water below the bridge, there was also excitement over who would find the murder weapon. Police took to the river using poles with magnets attached to them. Not only were they unsuccessful, they also ended up having to chase away locals who were showing up in boats, using rakes to try to snag the gun. Of course, when rumors of a "professional diver" being sent for circulated in Dayton, the riverbanks were crowded with folks hoping to see such a sight. Sure enough, professional diver Ben Graham arrived, causing quite a commotion in his robotic-looking suit with the oversized metallic diving helmet and the air tubes coming out the top. Thousands of people lined the banks of the Stillwater as Graham began the first of several dives, hoping to be able to say they were there when the murder weapon was finally found. It never was.

On December 14, 1896, the trial of Albert Frantz began at the Montgomery County Courthouse. Crowds were so large that extra security was brought in to protect the defendant. Frantz would be represented by five lawyers, including Colonel Robert M. Nevin, John H. Kreitzer and William Van Skaik. The state was represented by Charles H. Kumler, B.F. McCann, Henry Murphy and Charles Patterson. During opening remarks, Patterson stated that Frantz was guilty because "surgical science proved beyond a doubt that Bessie Little, a young girl, unfamiliar with the use of firearms, a woman with the natural physical weakness of her sex, could not have fired two large bullets."

Patterson also used the opening remarks to call into question Frantz's behavior immediately after Little was shot. What innocent person would have behaved the way Frantz did? Most would have immediately tried to revive someone who had just shot themselves or, at the very least, called out for help. Frantz didn't do any of that. In fact, the prosecution argued, Frantz's immediate reaction was to try to dispose of the evidence.

All in all, the prosecution had a lot of things stacked in its favor, including the fact that Frantz admitted being there for the shooting. As

for the gun itself, while it was never recovered, prosecutors were able to bring in witnesses who testified that Frantz had purchased a gun similar to the murder weapon shortly before Little was killed. Then there was the matter of Frantz's horse and buggy, along with any evidence they may have contained, conveniently being lost in a fire officially deemed "arson" the night after Bessie Little's death.

As for the "surgical science" Patterson alluded to in his opening remarks, that ended up being the most shocking part of the trial. That's when Bessie Little's head, contained in a glass jar, was brought into court, causing several members of the audience to faint and have to be carried from the courtroom. The head was brought in so that the path of the bullets could be shown to the jury in an attempt to show how either one of the shots would have killed Little instantly, making it impossible for her to fire a second shot.

The defense, on the other hand, seemed resigned to the fact that it would be unable to get its client completely off. Instead, it attempted to get the first-degree murder charge, which would bring the death penalty, reduced to second-degree murder. As such, the defense presented Frantz as a fine, upstanding citizen. What's more, the defense added, Frantz was madly in love with Bessie Little and would have liked to have married her, were he not yet of legal age to do so.

The jury wasn't buying it. Deliberations lasted only about two hours before the jurors returned a verdict: guilty of murder in the first degree. Based on the verdict, the judge sentenced Albert Frantz to die in Columbus's electric chair on Friday, May 13, 1897.

There were several delays, but shortly after midnight on November 19, 1897, Albert Frantz made his way to the electric chair. Hundreds of people, many of whom had been waiting for hours, tried to cram in to view the execution. More than one hundred of them were able to make their way inside. Hundreds more, many of them intoxicated, stood outside on the street, yelling and cheering.

It's interesting to note that in 1897, Ohio had officially changed its method of execution from hanging to the electric chair. In fact, only three people had been executed via the Ohio electric chair prior to Frantz. Those carrying out his execution had not yet perfected the procedure. As a result, electrical current had to be shot through Frantz's body several times before he was officially pronounced dead.

The next day, local papers announced, "Bessie Avenged, Frantz Pays the Penalty of Her Murder." Shortly after the execution, Frantz's body was claimed by his family, and he was buried in a private cemetery. With that,

the sordid case of Albert Frantz and Bessie Little came to a close. Eventually, even the traffic at the murder site, the bridge, broke up. But while the memory of the case faded, legendary tales never totally go away. As a case in point, today, even though more than one hundred years have passed and the infamous bridge has long since been replaced, old-timers still refer to the structure as the Bessie Little Bridge.

THE LEGEND OF HATCHET MAN

They say that within every good urban legend is a kernel of truth. Take, for example, the urban legend surrounding Logan County's Harrod Cemetery. This hallowed graveyard is said to be haunted by the angry spirit known as Hatchet Man, who wanders the cemetery late at night brandishing, you guessed it, a hatchet. It seems that while he was alive, this upstanding citizen murdered his entire family with an ax, save one of his sons. When he was executed for his heinous crime, unthinking townsfolk made the decision to bury Hatchet Man in the cemetery, right next to the family he slaughtered. For this reason, Hatchet Man's ghost can't rest in peace. Well, that and the fact that he's still looking to murder the son who got away. No worries: Hatchet Man will take your life in place of his son's if he gets the chance.

Heck of a story, huh? But none of it is true, right? Wrong! Believe it or not, there really was a character who became known as Hatchet Man. What's more, at least one of his victims is indeed buried inside Harrod Cemetery. Now for the really creepy part: Hatchet Man tended to target members of his own family.

Officially, the man who would become Hatchet Man was born Andrew Hellman on June 24, 1792, in the city of Worms, Germany. He is believed to have immigrated to the United States around 1817, settling in Baltimore, Maryland, and gaining employment as a merchant tailor. Years later, a newspaper piece looking back at Hellman's life conjectured that it was during this time that Hellman began "to have imbibed a lasting dislike to the whole female race."

In 1820, Andrew Hellman moved to Virginia, although it's not clear why he moved or if he had a specific destination within Virginia in mind. Once in Virginia, however, Hellman had a chance meeting with George Abel, a German farmer with a rather large family and an even larger farm. Since Abel was constantly looking for people to help on the farm, Hellman immediately found work there and was able to board there, as well.

In the spring of 1821, Hellman decided to return to Baltimore. He returned to Virginia a few months later. This time, Hellman had a specific goal in mind: to marry George Abel's daughter Mary. It seems that, during his time on the Abel farm, Hellman had taken a liking to Mary. George must have taken a shine to Hellman, as well, for he gave his blessing. A few months later, in December 1821, Mary and Andrew were married. The couple moved into a home near the Abel property and wasted no time starting a family, although some would whisper that they had already gotten a jump on that and that this was the real reason for the short courtship. Regardless, on August 8, 1822, the couple gave birth to their first child, Louisa Hellman.

Those who knew the family said that while Mary was quite pleasant to be around, the same could not be said for Andrew. He was described as "sullen" and "brooding" and was known to be prone to angry outbursts, often over the most trivial of things.

On September 27, 1823, Mary gave birth to the couple's first son, Henry. This event seems to have been Andrew Hellman's breaking point; almost as soon as the child was born, Hellman denied it was his and openly accused Mary of having been unfaithful to him on many, many occasions. Friends and family did not give the marriage long to last, especially since Andrew's outbursts were becoming more violent and frequent. Still, Mary seemed determined to make things work, and in June 1827, a second son, John, was born.

It was around this time that Mary's father, George, began to accept the fact that he was getting on in years. With that in mind, he began looking for a way to set each of his children up before he shuffled off his mortal coil. His solution was to purchase several tracts of land across Ohio and give one to each child. Mary was given land in Carroll County, and she and her family left Virginia in 1831. Upon arrival in Ohio, though, Andrew refused to live on the land Mary had been given, instead purchasing his own property nearby, where he lived alone. This would seem to be taken as a sign that Andrew wasn't interested in being married anymore, but by all accounts, Mary carried on and tried to keep her marriage intact.

In the spring of 1836, Andrew and Mary made the decision to move to Logan County, Ohio, where two of Mary's brothers, George and John, were

living. Mary was ecstatic; she felt that moving closer to her brothers might improve things between herself and Andrew. It didn't. In fact, it may have only made things worse.

About a year after their arrival in Ohio, Mary went into the kitchen and poured herself some milk before being distracted and leaving the kitchen. Upon returning a short time later, Mary went to take a drink but noticed that the top of the milk was covered with "a quantity of white powder, which had at that moment been cast upon it." Since the powder hadn't been there earlier, Mary immediately thought someone had thrown it into the milk in order to poison her. Her husband, Andrew, was the only other person in the house at the time. Mary asked Andrew, but he claimed to know nothing of the white stuff that had mysteriously shown up in her milk. With no proof that Andrew was the guilty party, or if the white substance was indeed intended as poison, Mary discreetly poured the milk out and carried on as if nothing had happened.

Sadly, this would not be the last time there were rumors in the air regarding Andrew's attempts to poison a member of his own family. In April 1839, all three Hellman children—Louisa, seventeen, Henry, sixteen, and John, twelve—suddenly fell deathly ill. Louisa and John died almost immediately. Henry would eventually recover, but only after enduring several agonizing days of severe illness.

The immediate reaction of neighbors was that the children had been poisoned. Quite naturally, Andrew was the prime suspect. He continually denied poisoning them, and no evidence was ever found. Still, Mary was convinced that Andrew was to blame. What's more, she couldn't help but think that her husband had to be enraged at the fact that the only child to survive, Henry, was the one he had publicly disowned. Mary was sure that Andrew was simply biding his time and waiting for his next opportunity to kill Henry. For that reason, Mary looked for any excuse to keep Henry from being left alone with Andrew.

Such a situation arose several months later, on September 26, 1839. On receiving news that her brother George was sick and unable to work, Mary jumped at the chance to send Henry over to help out around her brother's farm. Henry readily agreed and left that very afternoon, telling his mother he would return in a few days. This would be the last time Henry saw his mother alive.

Two days later, George's wife, Rachel, stopped by the Hellman house to chat with her sister-in-law. As she entered the house, she was met by the sight of Andrew, lying in bed, wide awake and covered in blood. When asked

what had happened, Andrew claimed that at some point during the evening of September 26, he had been awakened by a knock at the front door. When he answered it, he was immediately attacked by two men who beat him with a club. Andrew was unable to explain how he had ended up back in bed, only that he had been there quite some time, as the loss of blood made him unable to stand up.

When asked where his wife was, Andrew is said to have replied, "I do not know. Go and see." Rachel immediately began searching the house. When she opened the door to a room at the back of the house, she was met by a grisly scene, which the *Baltimore Sun* described this way:

> *In the centre of the room lay the mangled corpse of the poor wife, with her blood drenching the floor, whilst the ceiling, walls and furniture were also heavily sprinkled with the streams which had evidently gushed from the numerous wounds she had received in the dreadful struggle.*

Obviously, on seeing this, Rachel chose to make haste from the house and went to the home of John Abel, as he was the closest relative. John immediately gathered a large group of people, and they descended upon the Hellman house.

Andrew held fast to his story that he had been brutally attacked by two robbers in the middle of the night. This, despite the fact that a careful examination of Andrew's body turned up not a single scratch or wound. Simply put, the blood Andrew was drenched in wasn't his own. It turns out that he was bathed in the blood of his wife.

A search of the house ensued, and that's when things really started to look bad for Andrew. Pieces of his bloody clothing were found all over the house, as if he had simply discarded them. His knife was found hidden inside the fireplace hearth. The knife, like Andrew himself, was covered in blood. Approximately fifty yards from the house, the alleged murder weapon, Andrew's ax, was found. Not long after, Andrew Hellman was arrested. While in jail awaiting trial, he continued to say he was innocent. When he admitted hiding all the money in the house to make it look like a robbery had occurred, authorities looked at that as being a full confession.

The wheels of justice must have turned slowly back then; after being confined for over a year, Hellman had yet to stand trial. Being incarcerated in the same place for over a year really gives one the opportunity to get a feel for the place. And that's just what Andrew Hellman did. In doing so, he saw a means for escape. On the evening of November 13, 1840,

Hellman managed to slip out of his chains and escape into the night. A multiday search of the area turned up nothing. It was as if Andrew Hellman had simply vanished. Meanwhile, Henry Hellman, who had been forced to bury his mother out at Harrod Cemetery, next to his two recently departed siblings, was trying to pick up the pieces that had been his life.

Had Andrew Hellman simply been able to control his temper or, at the very least, stay away from sharp objects, this story would end here. But, as it would turn out, Hellman was incapable of doing either.

Let's leave Ohio for a bit and journey to Maryland, fast-forwarding to the year 1843—April 16, to be exact. Catherine Hinkle was on her way to the Baltimore-area home of her sister, Malinda Horn. Catherine was concerned because she hadn't seen her sister in almost a month. In fact, no one had seen Malinda anywhere. To make matters worse, whenever Catherine questioned Malinda's husband, Adam Horn, about his wife's whereabouts, he always seemed to fumble a bit before making up some sort of excuse. Today, Catherine was determined to get to the bottom of things.

When she arrived at the home of her sister, Adam Horn was sitting out on the porch. Once again, he appeared to be making up excuses, claiming to have seen his wife a moment earlier and then quickly saying she went away to visit with some friends. Not satisfied, Catherine left, but not before secretly vowing to return with a search party.

That's exactly what Catherine did. She gathered a group of people, and they began searching for any sign of Malinda as they made their way to the Horn residence. Approximately one-fourth of a mile from the Horn residence, a shallow grave that appeared to have been recently dug was found. There, wrapped in what was described as an old coffee bag, was Malinda Horn—or at least part of her. Her torso was there, but her arms, legs and head were all missing.

Realizing this missing-persons case was now officially a murder, the group made its way to the Horn residence. Finding no one home, the people nonetheless proceeded to investigate. Before long, Malinda's arms and legs were located, wrapped in the same sort of coffee bag in which her torso had been discovered. Adam Horn's shoes were also recovered, caked in similar clay and mud that had been at the shallow grave. Adam, however, was nowhere to be found.

In April 1843, Adam Horn was arrested in Philadelphia. While in custody, he not only admitted to killing his wife, Malinda Horn, but also to murdering his other wife in Ohio. Horn must have noticed the perplexed looks the

police officers were exchanging, because it was then Horn admitted that his real name was Andrew Hellman.

Adam Horn was formally charged with the murder of Malinda Hinkle. Officially, he was charged nine times, one for each of the ways he attempted to kill his wife:

> *With a hatchet*
> *With a knife*
> *With a wooden club*
> *With a stone*
> *With his fist*
> *By dashing her against the ground*
> *By strangling with a cord round her neck*
> *By strangling or choaking* [sic] *with the hands*
> *By pistol shot, through the head*

While Horn was in jail awaiting trial, on the afternoon of Wednesday, May 24, a local tanner who lived near the Horn residence fired up his burn pit and noticed something strange in the middle of the flames. Malinda Horn's head had finally been found.

Adam Horn's trial began in November 1843. It didn't last very long, but it was still covered extensively by newspapers across the United States. Full pages were often devoted to the trial. Outside the Baltimore courthouse, streets were packed with people wanting nothing more than to catch a glimpse of the man some people were calling everything from "the modern Bluebeard" to "the greatest criminal ever tried in this country."

On Tuesday, November 28, Horn was found guilty of murder in the first degree. Soon after, it was officially decreed that "Adam Horn, otherwise called Andrew Hellman, hang by the neck until he be dead."

On the morning of Friday, January 12, 1844, Adam Horn (aka Andrew Hellman) made his way to the gallows to accept his punishment. He remained calm and reserved, despite the carnival-like atmosphere around him. This was, after all, the public execution of someone many considered one of the wickedest men alive.

In the end, while Hellman/Horn would admit to killing both of his wives, he went to his grave denying ever trying to poison his children back in Ohio.

Hellman's grave, specifically its location, appears to be something that is lost to time. There is nothing in the official record concerning what became of the body, other than that Hellman's son Henry came in from Ohio and

TRIAL OF ADAM HORN, FOR MURDER.

Right: A rather unflattering illustration of Adam Horn created during his trial. *From the* Baltimore Sun, *Thursday, November 23, 1843.*

Middle: For months, Adam Horn's crimes made for great newspaper fodder. *From the* Jeffersonian, *Thursday, January 4, 1844.*

Bottom: A mere two weeks after Adam Horn's execution, people began offering "lifelike" busts of him. *From the* Baltimore Sun, *Friday, January 26, 1844.*

HISTORY OF HORN.

The Modern Blue Beard--His birth at Worms---Disposition to Roam---Narrative of his dreadful crimes---His children--He is no doubt the greatest criminal ever tried in this country.

BUST OF ADAM HORN.—A. PONCIA, Figure Maker and Moulder, No. 40, Baltimore street, has just completed the Bust of Adam Horn, the murderer. The figure is such a correct representation of the original that at first sight it would be recognized as that or Horn. Persons wishing the bust of the notorious murderer, can procure them at the above place. j26 1t*

claimed it. While it is certainly possible that Henry returned his father's body to Ohio and had it interred with the rest of his family at Harrod Cemetery, it seems rather unlikely. Granted, we're talking about Henry's father here, but it was this very father who continually disowned Henry almost his entire life. But if he did bury his father inside Harrod Cemetery, he did so secretly and without a tombstone, as cemetery records do not show the burial of an Andrew Hellman or Adam Horn whose dates match those of the man involved in this sordid tale.

As for me, I take a kind of fiendish glee in the fact that no one knows where Hatchet Man's final resting place is. Because those are the sorts of things that make historical facts grow into urban legends. Put it this way: If we don't know where Hatchet Man's final resting place is, that could mean that he doesn't have one. And, without a place to rest, Hatchet Man's angry spirit could be anywhere…maybe even right behind you as you're reading these very words!

OPEN SEASON ON CENTRAL OHIO OUTDOORSMEN

Many local legends focus on the woods and the creepy things that are said to lurk inside them. Most of the stories will contain references to Bigfoot or other assorted monsters. Then, of course, there are the vague tales about criminals, cults and even serial killers taking up residence deep within the forest, where they can commit their evil deeds far away from public view.

Outdoorsmen, known to spin a tale or two to frighten and entertain friends and relatives, for the most part dismiss such legends. They are, after all, going into the woods, in most cases, armed and fully capable of protecting themselves from a wide range of things that could potentially wish to do them harm. So it's not surprising that when stories started circulating across Central Ohio in the early 1990s that a serial killer was literally targeting Ohio hunters and fishermen, most scoffed at the idea. As it would turn out, the tales were true.

The story began on the morning of April 1, 1989. Donald Welling, thirty-five, was out walking or jogging on Tuscarawas County Road 94 when he was shot and killed. It was later determined that Welling had been killed by a single shot to the heart, fired from a .30-caliber rifle. Unfortunately, there were no witnesses. An investigation was started, but there was very little evidence at the scene, and a thorough background check of Welling, as well as interviews with family and friends, failed to turn up a single lead. By all accounts, it appeared as though Welling had simply been in the wrong place at the wrong time and had been fatally

struck by a stray bullet fired by someone hunting or target practicing. Still, the fact that Welling had been hit directly in the heart led some to believe that the act might have been intentional.

On November 10, 1990, Jamie Paxton, age twenty-one, was bow hunting at a Belmont County strip mine when he was shot and killed at approximately 8:30 a.m. The initial report indicated that the shooting had been a hunting accident. That quickly changed, though, once authorities arrived on the scene and determined that Paxton had been shot three times. From what they were able to piece together, it appeared as though someone had stopped their car alongside the road that passed by the strip mine Paxton was hunting in and simply started firing before driving off. Once again, there was little if anything in Paxton's background to suggest something like this might happen. Of course, police couldn't ignore the fact that, like Donald Welling, Paxton had been shot by a .30-caliber rifle.

Less than three weeks later, on November 28, police received a call about a shooting at a strip mine near Dresden, Ohio. When they arrived, they found thirty-year-old Kevin Loring dead from an apparent single gunshot wound to the head. Loring had been deer hunting in the area, so his death was originally considered an accident. Still, there were many who began to suspect that there was some sort of connection among the recent shootings, even though no obvious connection could be found. Besides, it seemed strange that someone would be randomly targeting outdoorsmen for no apparent reason.

Police spent the remainder of 1990 and most of 1991 tracking down leads in the three cases. All of them turned out to be dead ends. Multiple suspects were looked at, but all had alibis and none could be tied to all three cases. Thankfully, there were no more shootings that could be connected to the three already on record, so they began to look like isolated incidents. Then, on November 4, a mere six days before the first anniversary of Jamie Paxton's death, a letter showed up at a local Martin's Ferry, Ohio newspaper, the *Times Leader*, that confirmed authorities' worst fears: They were indeed dealing with a serial killer.

Addressed to the editor, the letter began, "I am the murderer of Jamie Paxton." The letter then went on to provide details that only the murderer would know, including that the weapon had been a .308 bolt action rifle with 165-grain softpoint bullets. The letter also included a description of Paxton's vehicle and where it had been parked the day of the murder.

The author of the letter then made it clear that Jamie Paxton was a complete stranger and had simply been killed "because of an irresistible compulsion that has taken over my life." There were even hints of more

OHIO NEWS

Hunters not intimidated by threat of serial killer

This headline implies otherwise, but the notion of a serial killer targeting outdoorsmen was beginning to make people nervous. *From the* Akron Beacon Journal, *Monday, August 31, 1992.*

victims, with the author going so far as to mention that he (or she) met "the definition of a serial killer" because they had killed three or more people "with a cooling-off period in between."

The letter concluded with these words: "I've had dozens of opportunities since that November day to kill others in Ohio and other states and chose not to. Let's hope that this will be the end of the killing but at this point, I don't know." The letter was signed "The murderer of Jamie Paxton."

After reviewing the letter, authorities confirmed that it had most likely been written by Jamie Paxton's killer. The letter's mention of having killed "three or more" caused police to start reexamining unsolved shooting deaths, both in Ohio and in neighboring states. The killer's letter provided a treasure-trove of information that authorities hoped would be enough to identify and apprehend the guilty party before he struck again. They would not be so lucky.

On March 14, 1992, Claude Hawkins, forty-eight, of Mansfield, Ohio, was enjoying a day of fishing at Wills Creek Dam. Sometime between the hours of 10:00 a.m. and 2:00 p.m., he was shot and killed by a single bullet from a 6.5 Swedish Mauser rifle that struck him in the back. Hawkins's death would take this case to a whole new level—it was determined that Hawkins had been murdered on federal property, so it became a federal case and was officially turned over to the FBI.

The FBI was still in the process of sorting through its list of potential suspects when, on April 5, forty-four-year-old Gary Bradley was gunned down while fishing at a pond near State Route 83 in Caldwell, Ohio. Bradley had been shot twice in the back by the same type of rifle used to kill Claude Hawkins: a 6.5 Swedish Mauser rifle. Clearly, at least these two cases were connected.

During this time, a sixth man, Larry Oller, was shot at while hunting, but he was unharmed. Sensing that the killer was now getting bolder (his attacks were coming closer together), the FBI and local authorities issued a statement asking the public for help in identifying the shooter. Hundreds of tips came flooding in, but none led anywhere until a tip came in from a local who said Thomas Dillon might be someone involved in the shootings.

Thomas Dillon was well known to Ohio law enforcement. In August 1991, he had been charged with illegal target shooting when a game warden caught him outside a Stark County state hunting area. A search of Dillon's vehicle turned up a handgun that was equipped with a silencer, which was turned over to federal authorities. Dillon had recently pled guilty to a charge of possessing an illegal silencer and was currently awaiting sentencing. After much discussion, the task force decided someone should keep an eye on Thomas Dillon.

That assignment fell to Walter Wilson of the Tuscawaras County Sheriff's Department. Wilson didn't get much at first, but over the course of several weekends, he watched Dillon purchase multiple firearms at various gun shows across Ohio. This was clearly a violation of the plea agreement Dillon had agreed to during his case regarding the illegal silencer. It wasn't much to go on, but the task force felt it was enough to get a search warrant for Dillon's house.

Dillon's house was searched on November 26 and 27, 1992. Based on evidence recovered, authorities arrested Dillon on November 27 and charged him with violating his plea agreement by purchasing firearms. At his December 2 hearing in Akron's federal court, it was formally announced that Dillon was "the prime suspect in the slayings of five outdoorsmen." Dillon was ordered held without bond.

Two days later, a man contacted authorities to say that he had purchased a gun from Thomas Dillon several months ago and wanted to turn it in. The gun the man eventually turned over was a Swedish Mauser rifle, the same type of gun that had been used to kill victims no. 4 and no. 5, Claude Hawkins and Gary Bradley. The man stated that he had purchased the weapon from Dillon on April 5, 1992—the same day Gary Bradley was shot. Suddenly, things weren't looking so good for Thomas Dillon.

With the appearance of what looked to be the weapon that had killed two outdoorsmen, authorities spent the remainder of 1993 preparing to charge Dillon with the murders of Claude Hawkins and Gary Bradley. In January 1993, Dillon was formally charged with two counts of aggravated murder. He pled not guilty to both charges, but since the prosecutors had asked for death-penalty specifications on both counts, Dillon asked his defense team

Suspect in killings boasted of violence

• Confidential documents reveal man named in serial slayings bragged of his ability in shooting animals

After his arrest, it became clear that Thomas Dillon fit the profile authorities had created. *From the* Akron Beacon Journal, *December 9, 1992.*

to seek out a possible plea bargain. Prosecutors were having none of that, though. In fact, when the original March 1993 trial got pushed back to September, they decided they had enough evidence to indict Dillon for the murder of Jamie Paxton, as well. Dillon originally pleaded not guilty to that charge, but on July 2, 1993, in what many saw as a desperate attempt to escape the death penalty, Thomas Dillon confessed to the shooting deaths of the three men he had initially been charged with—Claude Hawkins, Gary Bradley and Jamie Paxton. Additionally, he confessed to the murders of Kevin Loring and Donald Welling. He was sentenced to five consecutive terms of thirty years to life.

When pressed for a motive, Dillon seemed rather proud to admit there wasn't any. He simply drove around until he found someone all alone. Then, if he heard a voice in his head, he knew he had to shoot them. At the time of his confession, Dillon was unrepentant, although he did feel some remorse for shooting Jamie Paxton, who was only twenty-one at the time of his death. That remorse was what prompted Dillon to write the letter to the local newspaper. "I felt bad about the kid," Dillon would tell investigators. "I thought he was 30, 35. I didn't know he was that young…he had his whole life ahead of him and I blew him away, you know, I felt sorry for him."

Thankfully, no one felt sorry for Thomas Dillon. He remained behind bars for the rest of his natural life. He died on October 21, 2011, at the age of sixty-one in the prison wing of the Corrections Medical Center in Columbus, Ohio.

13

THE SCANDALOUS DR. SNOOK

At first glance, Columbus's James Howard Snook hardly seemed like someone who would be involved in something dubbed "the crime of the century." By all accounts, he was a successful, well-liked professor, a good family man, even an Olympic gold medal champion. Perhaps that's why, once Snook's name began being associated with a vicious, heinous murder, national newspapers latched onto him and refused to let go.

It all began on the morning of June 14, 1929. Two teenagers, Paul Krumlauf and Milton Miller, were making their way through the tall grass and weeds surrounding a shooting range just outside Columbus for a day of target practice when they stumbled across what they initially thought was a pile of trash. Once they realized they were staring at the body of a young woman, they immediately alerted authorities.

The body was later identified as twenty-three-year-old Theora Hix, a medical student. Hix had recently been reported missing by her roommates, Alice and Beatrice Bustin. Once she had been identified, authorities began interviewing Hix's friends and coworkers in an attempt to re-create her final hours and, more importantly, to determine who would want to kill her and why. Almost immediately, the name "Dr. Snook" kept popping up as a possible suspect. At first, police dismissed the rumors, as Snook was a well-respected member of Columbus society. But when more and more people pointed to Dr. Snook as someone who might be involved or, at the very least, have pertinent information, police decided to bring him in for questioning.

When he arrived at the police station, the tall, balding and bespectacled James Howard Snook hardly looked capable of murder. The forty-nine-year-old husband and new father was enjoying a successful career as the head of the Department of Veterinary Medicine at The Ohio State University. A background check of Snook turned up nothing but accolades and accomplishments that included his being a founding member of the Alpha Psi veterinary fraternity as well as inventing the Snook Hook, a surgical instrument used to spay animals. He was also the winner of an Olympic gold medal as a member of the U.S. Pistol Team at the 1920 Olympics in Belguim.

So, it came as a shock to everyone when Snook admitted to police that for the past three years, he had been involved in an affair with Theora Hix. When pressed, Snook stated that the relationship had been incredibly sexual in nature and that he had even rented an apartment in Columbus's Short North so that they could be intimate in private.

The more Snook admitted, the more police pressed him for additional information. Eventually, Snook admitted to killing Hix. In a confession that Snook would later imply was coerced, he said that he and Hix drove out to the shooting range to talk in seclusion. Once there, Hix became enraged over Snook saying he was making plans to take his wife and infant daughter to see Snook's mother. Despite Snook's attempts to calm her, Hix began shouting threats that she would shoot his entire family. When Hix began reaching into her purse for something, Snook thought she was going for a gun. The two began to struggle. As they struggled, Snook reached into the car's backseat for something with which to defend himself. Finding a hammer, Snook said he struck Hix with it. When she kept attacking him, Snook struck Hix again. And again.

Eventually, Hix got out of the car. Snook said he followed her and may have struck her again. When she fell, Snook realized that, while her wounds were certainly fatal, she was still suffering. It was then that Snook said he decided to put Hix out of her misery by slitting her throat with his pocketknife.

When Snook finished his statement, police realized they had more than enough evidence and promptly charged Dr. Snook with Theora Hix's murder. Local newspapers got wind of the arrest, and all hell broke loose.

The specifics of the Snook case is a prime example of what sells newspapers: scandal. And the Snook case had more than its fair share of scandalous things, so much so that newspapers had their pick of what they wanted to cover first. There was the obvious—a middle-aged, successful professor carrying on a three-year affair with a girl half his age before killing her. Then there was the idea of Snook renting what became known as a "love

nest" for their rendezvous. Snook's appearance also helped lend credence to the whole "Jekyll and Hyde" persona some newspapers played up. Whatever the angle, the news spread quickly across the country, so much so that even before the trial began, it was being called the "trial of the century."

The trial of Dr. Snook began on July 24, 1929, in a packed Columbus courtroom, which included dozens of reporters whose sole job was to cover the trial. As soon as the defense presented its case, it was clear the plan was to try to show Theora Hix in a bad light in order to play up Snook's claim that the murder was a result of self-defense. When hints of bizarre sex acts and drug use began floating around, it was as if the reporters began literally licking their chops.

The prosecution presented its evidence, which, in addition to Snook's confession, included Hix's blood in Snook's car as well as the murder weapons—the hammer and the pocketknife—being found in Snook's possession. Then it was the defense's turn, and it didn't hold back. As far as the defense was concerned, Theora Hix was a manipulative, sex-crazed drug addict who had managed to wrap Dr. Snook around her finger. She was prone to fits of rage, during which she was capable of almost anything. It was one of these very fits that led to Dr. Snook having to defend himself and, unfortunately, kill Hix. Every word was lapped up by the press and spit back out the following day in newspapers. People reading the news began showing up in droves outside the courthouse, hoping to get inside and hear some of the sordid details themselves. And, of course, they were waiting with bated breath to hear what Dr. Snook himself would say when he took the stand.

When he did, Dr. Snook did not disappoint the media. Hix, Snook testified, was very upfront about her sexual prowess and even went so far as to tell Snook he needed to brush up on things if he intended to keep up with her. To help him, Hix even provided Snook with books to read on the subject. She was also often rough during sex and enjoyed taking drugs before intercourse.

Concerning the murder itself, Snook did not deny killing her, but there were several differences from his original confession. While he had originally said he and Hix went out to the shooting range "to talk," under oath, he said that they were looking for an isolated place to have sex in the car. Upon reaching the shooting range, they attempted to have sex, but Snook said the car ended up being too small. Snook next described an episode of oral sex that ended with Hix biting Snook. When he reacted angrily, Hix got mad and began threatening Snook and his family. As in his original confession, Snook said that when Hix began reaching into her purse, he believed it was for a gun and took action to defend himself.

So scandalous was James Snook's crime that a Scripps-Howard artist devoted an entire spread to the confession. *From the* Pittsburgh Press, *June 23, 1929.*

Dr. Snook's execution made front-page news everywhere. *From the* Coshocton Tribune, *March 1, 1930.*

Snook's testimony on the stand was deemed so shocking that most of the reporters covering the case merely alluded to many of the details. A court stenographer, however, gathered up all of Snook's uncensored testimony and quickly published it as *The Murder of Theora Hix and Trial of Dr. James H. Snook.* It was promptly seized and destroyed by police, making it a sought-after collectors' item even today.

Dr. Snook's trial ended on August 14, 1929. Amazingly, the jury needed less than thirty minutes to find Snook guilty. Jurors would later remark that they could have done it even sooner, but they needed several minutes to discuss the procedure for reaching a verdict before they actually voted. For the murder of Theora Hix, Dr. Snook was sentenced to die in the electric chair.

The wheels of justice moved more quickly back then than they do today. Snook's attorneys did file appeals, all the way to the United States Supreme Court, but when these had been exhausted, the final date for execution was set for February 28, 1930, at the Ohio State Penitentiary in Columbus.

On the evening of February 28, after a dinner consisting of fried chicken that had been cooked by the warden's wife, Dr. James Snook was led into the execution chamber at 7:02 p.m. At 7:07, the switch was thrown, and at precisely 7:11 p.m., Snook was officially declared dead.

Following the execution, Dr. Snook's body was taken to King Avenue Methodist Church for a small, private service before being interred at Columbus's Green Lawn Cemetery. In an attempt to keep the press away, the decision was made not to use the doctor's last name and to simply mark the grave as "James Howard," thus creating the legend that Dr. Snook is not buried at Green Lawn Cemetery. He is, ironically, buried beneath a stone bearing the same name he used to rent the apartment for his secret meetings with Theora Hix.

PART IV

LEGENDARY PLACES

FRANKENSTEIN'S HUMBLE ABODE
IN KETTERING

Ask anyone who lives or has spent any time in the Dayton area how to get to Frankenstein's Castle, and they'll know exactly what you're talking about. Soon, you'll find yourself winding through Kettering's Hills and Dales Park on Patterson Boulevard. Suddenly, an old, abandoned stone tower will appear before you, looking down at you from the hillside.

Of course, most people don't think Frankenstein and/or his monster really live in the tower. Rather, many believe that it's a group of witches who have taken up residence inside as well as in the surrounding woods. Others swear the place is haunted, either by the ghost of a woman who jumped to her death from the top of the tower or by the ghosts of two people who were struck by lightning inside the tower while trying to seek a dry place to wait out a thunderstorm.

So what's the deal with this place? Is there a glimmer of truth to any of the strange tales surrounding this tower? Believe it or not, there is! First, let's take a look at the history of the tower, whose origins are about as mysterious as the ghostly legends surrounding it.

For starters, there is a lot of debate as to who built the tower and why. Given that the structure looks old, there's a popular legend that the tower was constructed "hundreds of years ago" as a lookout tower. Who the builders were looking out for depends on who you talk to. Some say American colonists were looking out for British redcoats. Others say that settlers were trying to thwart potential Native American raids. These are interesting theories, to be sure. While there is some confusion about the

tower's origins, most everyone agrees that it is a more modern structure, created in the 1900s.

The next person to be associated with the tower's construction was Dayton-area mogul John Henry Patterson, founder of the National Cash Register Company. In the early 1900s, Patterson was well known in the area and owned quite a bit of land nearby. In fact, Patterson's impact on the area directly around the tower can still be seen today. There is a large statue of Patterson a short drive away from the tower, and the tower itself overlooks Patterson Boulevard. The tower is even sometimes referred to as Patterson Tower or Patterson's Tower. It's not that far of a stretch for some people to assume that Patterson was responsible for the tower's construction. He wasn't.

The fact of the matter is that the tower was constructed around 1940 by the National Youth Administration, an organization that helped young adults learn a trade in order to enter the workforce. Described simply as a "lookout tower," the structure was created almost entirely out of stone salvaged from local condemned buildings. There is no mention of the tower being anything else than a cool place to visit, climb its fifty steps and take in the beautiful views. I personally found it interesting that the tower's construction was done under the direction of Earl Shock, the superintendent of the nearby public golf course, which had opened in 1919. There is thus always the possibility that Shock picked the tower's location to give people a bird's-eye view of his golf course.

What about the ghost stories? Well, one of the earliest to attach itself to the tower is said to have happened in the Civil War era. A local woman, distraught over receiving news that her husband had been killed in battle, climbed the tower and committed suicide by jumping off the roof. Her ghost now haunts the inside of the tower and can be seen in the woods surrounding it. When she's spotted in the tower, it's usually on the roof; sometimes, the ghost will even reenact her suicide by appearing to leap from the top of the tower. When her ghost is seen in the woods surrounding the tower, she is more often than not weeping.

It's a creepy story, to be sure, but it's also one that we can dismiss. The tower was constructed decades after the Civil War ended. There was thus no tower in place for the woman to jump off of.

The most popular and enduring ghost story concerns a young couple out for a stroll one evening when they get caught in a sudden downpour. Seeking somewhere dry to wait the storm out, they stumble inside the tower and make their way up the winding staircase to the roof, arriving

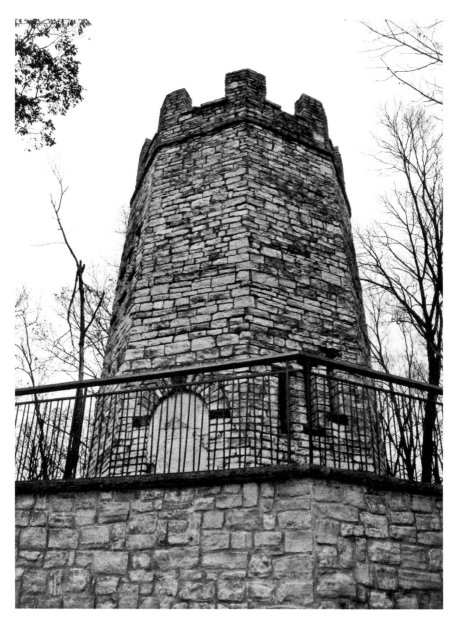

Whether it is referred to as Witch's Tower, Frankenstein's Castle or Patterson Tower, this edifice strikes a menacing pose as it looms over Patterson Boulevard. *Author photo.*

there just as a bolt of lightning hits the tower, electrocuting both of them. Today, the ghosts of the couple can allegedly be seen wandering up and down the staircase, especially on dark and stormy nights. What's more, the legend states that when the police found the couple, they discovered charred outlines of their bodies, forever burned into the tower walls at the exact moment the lightning bolt struck. It seems that no matter how hard park officials tried to get rid of the charred reminders of that fateful night, the stains refused to fade or be painted over. As a result, the park simply decided to seal up the entrance to the tower to keep people from seeing such a gruesome sight.

That story, believe it or not, does have its roots in an actual event. Sort of.

Shortly after 8:00 p.m. on Wednesday, May 17, 1967, local police received a call about someone having been injured at the tower. Upon arrival, they found two students from Bellbrook High School, a sixteen-year-old female and a seventeen-year-old male, inside the tower. Police located the male first. He was found unconscious at the foot of the stairs, just inside the entrance to the tower. The female was found, deceased, farther up the staircase. Both had suffered severe burns.

The boy was taken to a local hospital, where he would recover. He remembered very little of the incident, though. From what authorities were able to piece together, the pair had gone out to visit the tower when a sudden violent storm came up. The pair were coming down the stairs, the girl in the lead, when a bolt of lightning struck the metal gate that served as an entry point to the structure (it has since been removed and the opening closed up). The lightning then traveled up the staircase, striking both the girl and the boy. Since the girl was in the lead, she unfortunately bore the brunt of the lightning's force. The coroner officially concluded that her death was accidental.

Could this unfortunate couple be the ghosts that are said to haunt the tower? It is highly doubtful. For one, the facts don't fit the legend. The legend says that both people died inside the tower and that their ghosts can be seen walking up and down the staircase. In reality, only one person died in the tower. More than likely, since the tower already had a spooky past, once the real tragic event took place, bits and pieces of that were attached to the tower over time. This doesn't mean there aren't ghosts here. It's just that they're more than likely not in any way connected to the 1967 incident. Newer versions of the legend, no doubt ones created by people who were made aware of what happened in 1967, claim the ghost of a solitary female haunts the tower. To be honest, I think this is a classic

case of keeping a spooky legend alive by modifying it to fit reality. Either way, if you should ever find yourself driving along Patterson Boulevard on a dark and stormy night, keep a sharp eye out for a spooky-looking tower alongside the road. As you pass, don't be surprised if you feel a sudden chill or get a strange feeling in the pit of your stomach. Make a note of it if you do, because those feelings are the very things from which all great ghost legends, true or not, originate.

"SOME SAY IT'S THE DEVIL'S FIRE"

I was raised Roman Catholic, and it was instilled in me that the devil was lurking around every corner. I needed to be on my best behavior at all times, lest the ground suddenly open up and the devil himself reach up and pull me down into his fiery domain. It was pure nightmare fuel. Good thing I never visited New Straitsville, Ohio, in my youth, because, for a while, the whole "ground opening up and flames shooting out" thing was a common occurrence. Some people would have you believe the devil was to blame. However, the real culprit is an underground fire that's been burning under New Straitsville since 1884.

New Straitsville was founded by Lancaster banker John D. Martin in 1870. Martin had been considering the area for some time, due to its high concentration of coal. Martin wanted in on the coal business, but he made sure he went about it the right way. In 1869, a year prior to New Straitsville being founded, Martin brought together many of the local miners and organized the Straitsville Mining Company. He also became the company's first president.

In New Straitsville, Martin bought up hundreds of acres of land on which he planned to mine for coal. The land sat adjacent to where the tracks for the Columbus and Hocking Valley Railroad terminated. And, wouldn't you know it, Martin just happened to be an early stakeholder in that railroad. Needless to say, the New Straitsville branch of the Columbus and Hocking Valley Railroad opened in 1871, allowing Martin and the Straitsville Mining Company to easily load and ship their coal.

Ever the shrewd businessman, Martin was willing to sell off some of his property to others who wanted to mine for coal—for a price, of course. As more and more coal came out of New Straitsville, more people wanted in, and the town's population exploded. At its peak, more than four thousand people were crammed into the tiny town, most of them miners, some of whom had come from as far away as Europe in order to find work.

That work, however, was incredibly grueling and dangerous. On top of that, the pay wasn't all that great. Some miners were paid only for the coal they were able to dig. So, if a mine had to shut down for a day, miners were not getting paid. As a result, most miners essentially lived in poverty. There were fledgling unions in existence at the time, but since any miner caught talking about unions was almost certainly terminated on the spot, very few workers dared talk about them.

That all started to change by 1880. Several small local unions had decided to band together, forming the Ohio Miners Amalgamated Association in 1882. In the course of just a year, thousands of Ohio miners joined its ranks. The following year, "Ohio" was dropped from the group's name, and it became the Amalgamated Association of Miners of the United States. Many historians point to this organization's founding as one of the first steps toward the creation of a national trade union for miners.

Many local miners looked at the formation of a union as a positive thing. But the 1880s also brought something that would have a negative and lasting effect on the area: falling coal prices. Unable to keep up with the falling prices, mine owners were forced to do the unthinkable: they cut the miners' wages. The union stepped in and tried to rectify the situation, but it was unsuccessful. In June 1884, workers at the New Straitsville mine went on strike.

Work strikes are never pretty, but the one in New Straitsville was particularly volatile. In an effort to keep the mines open and profitable, owners were forced to call in non-union "strikebreakers" to pull the coal. In order to get to the mine, though, these workers had to walk past rows of out-of-work miners who had been living on the poverty line even before they went on strike. Heated arguments and violent confrontations became the norm around New Straitsville. And things were only going to get hotter.

While the exact details surrounding the fire's origin are a bit of a mystery, popular belief is that it was started in October 1884 by the striking miners in an attempt to shut down the mine and/or force the end of the strike in order to have extra manpower to put the fire out. Whatever the reason and whoever the guilty party, it is believed the fire was started by dousing filled

coal carts with crude oil and then pushing them into the mine. Legend also has it that more than one fiery mine car were shoved into mine shafts all over New Straitsville. True or not, at least one coal car is believed to have reached what was known as the Great Vein—a fourteen-foot seam of high-quality coal. Once it hit that, the fire began to smolder until finally erupting into what became known locally as the Devil's Fire.

As for the strike itself, it was over by March 1885. Unfortunately for the miners, their union was not successful. The miners ended up accepting lower wages as one of the terms of ending the strike.

For some of the returning miners, the first order of business was to put out the fire that had been burning for several months inside the mine. That was easier said than done. The initial thought was that they simply needed to seal off the entrance to the mine where the fire was and it would go out due to a lack of oxygen. It didn't take long to realize that even with the entrance closed off, there were far too many air pockets and ventilation shafts in the mine to fully cut off the oxygen supply. And, with what appeared to be a never-ending supply of fuel in the form of coal, there was no telling how long this fire would burn.

As New Straitsville entered the twentieth century, things only got worse. The fire continued to grow and spread, often resulting in the ground around the mines suddenly opening up. Flames, sometimes rumored to be in excess of one hundred feet tall, shot into the air. At the mine itself, working conditions became almost unbearable, as the miners often couldn't access certain areas due to the spreading fire. It was almost as if the miners were in a race against the flames to see who could get the most coal. In the end, the fire won out. All of the coal that could be safely removed from the mine was gone, and operations ceased.

All this time, attempts were being made to at least slow down the progression of the underground fire so that, maybe, coal could at least be pulled from neighboring areas. Nothing worked, though, and the fire kept spreading under the ground. As it spread, the people aboveground started exploring other resources to dig for, namely iron ore. Oil and natural gas were also starting to be considered as an alternative to coal. Then the Great Depression hit in 1929. For the most part, coal mining in New Straitsville was a thing of the past. People began to leave in droves.

Those who stayed behind, though, came to the conclusion that if they couldn't beat the fire, they would at least try to make some money off of it. By now, the fire had been burning nonstop for almost fifty years and had attracted the attention of media outlets across the United States. People

Journalist Ernie Pyle visits the mine fire with two local boys. *Little City of Black Diamonds/New Straitsville History Group.*

started coming from all over to see the Devil's Fire. And the people of New Straitsville were more than happy to greet them.

In what became something of a cottage industry, locals put up signs and billboards that pointed the way to the "biggest fire on Earth." Since the fire could be seen from multiple mine entrances, locals got into a friendly

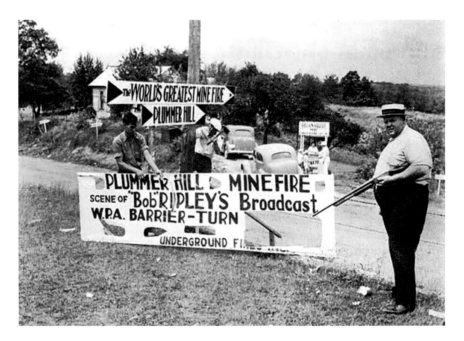

News spread almost as fast as the fire. For a time, the area around the mine became something of a tourist trap. *Little City of Black Diamonds/New Straitsville History Group.*

competition by drawing up maps, each claiming that theirs showed the location of the "real fire." Others went so far as to give locations on their property colorful names like "Devil's Garden" in order to lure more tourists in. Some even set up interactive displays of sorts on their property. For a price, visitors could watch people fry eggs over the top of one of the mine shafts or pull boiling hot water from their wells. Of course, there were those who said you didn't need a map to find New Straitsville. All one had to do was follow their nose, as the sulfur smell from the mine fire could be detected for miles. Plumes of smoke were also a common sight on the mountains.

Before long, it was considered unsafe to venture too close to any of the mine's entrances, for fear the ground would suddenly open up and swallow a person whole. But that didn't stop some locals from using that fear to their advantage: they used the mines to create moonshine. Those willing to risk entering the mines were pretty much assured they could work in secret, so it was the perfect location to set up a still. Before long, what people referred to as Straitsville Special moonshine became known all across the United States, causing some to dub New Straitsville the "Moonshine Capital of the World." Unlike the coal mining industry, moonshine making is one business

World-Famous Straitsville Mine Fire Still Smoldering After 84 Years

Years after the initial buzz faded, local newspapers still tracked the fire. *From the* Logan Daily News, *February 17, 1968.*

venture that continues to endure in New Straitsville. For almost fifty years, the town has been holding its Moonshine Festival. In 2012, the Straitsville Special Distillery opened in town.

As for the fire, it continues to burn. It has moved deep underground, though, so the giant flames leaping in the air or lapping at the entrance to the mines are things of the past. Smoke plumes can still be seen rising from the ground on occasion, though.

Since most of the fire is deep underground, it is hard to say with any certainly just how far it has spread. It is estimated, however, that the fire has consumed over two hundred square miles of coal since it was first ignited. At this point, everyone seems resigned to the fact that there's no way to put the fire out and that it will simply continue to burn as long as it has oxygen.

Today, most of the property affected by the mine fire belongs to the federal government, which turned it into the Wayne National Forest. A complete survey of the property is yet to be completed, but the government has already identified "thousands of mines out there." The long-term plans for the area include addressing the many environmental issues the mine fire has brought with it and making things safe again. Currently, there are no plans to try to stop the fire.

STONEWALL CEMETERY

Old family cemeteries are nothing new to Ohio. Get outside the city limits of any Buckeye city or town and the landscape is literally dotted with small, often nondescript, final resting places. And then there's the one sitting in the middle of a field just outside of Lancaster. Like most family cemeteries, this one is rather small, with only a dozen or so graves. The marvelous stone wall that almost completely encircles the cemetery is what really makes this one stand out. Plus, it's probably the only cemetery that, according to legend, was owned by every president of the United States who held office since the 1800s.

The brainchild for what would become known as Stonewall Cemetery is Nathaniel Wilson. Nathaniel Wilson III, to be exact. As a boy, Nathaniel moved with his family from the Pennsylvania Homestead in 1798 to the outskirts of what would become the village of Lancaster two years later. As one of the first settlers in the area, the Wilson family had to work many long hours to establish their farm. But Wilson's father, Nathaniel Wilson II, took the opportunity to instill in his son a sense of pride as well as respect for one's fellow man, both living and departed. There were also heavy doses of Bible and scripture reading to reinforce those ideals.

Nathaniel II died in 1815 and was buried in the old city cemetery in Lancaster, Ohio. As for the Wilson property, it was willed to Nathaniel III. Shortly thereafter, Nathaniel made the decision that there should be an area on his property officially designated as a cemetery. He chose some land on the eastern side of his property and declared it the Wilson Family Cemetery.

Wilson had listened and learned from his father when it came to having reverence to the dead. As such, he began to entertain the idea of constructing a large stone wall around the cemetery. But he wasn't done there. For reasons that aren't entirely clear, Wilson felt that the cemetery should be deeded to someone who would ensure it would be looked after for many, many years. What better person than the president of the United States of America?

On October 24, 1817, Nathaniel Wilson III filed paperwork officially deeding the tract of land with the cemetery on it to James Monroe, the current president of the United States, in trust of the Nathaniel Wilson family and heirs for them to use the cemetery. It was specifically noted that the cemetery was not only for President Monroe, but also for all of his "successors in office, forever." This meant that every president, beginning with Monroe, would technically take over ownership of the cemetery the moment they entered office. This is why locals began referring to the burial ground as President's Cemetery or the President's Burying Ground.

Why would Nathaniel Wilson III choose to deed his family cemetery to the president of the United States? There is a lot of speculation surrounding this. Some say he was just being generous, or that he was following what he believed were his father's wishes in treating the dead with respect. Perhaps he felt that, by deeding the cemetery to the president, the government would send people to watch over it, thereby protecting it from vandals. Of course, there's always the idea that Wilson hoped a U.S. president or two would choose to be buried next to where he was planning to rest in peace. Regardless, there is little evidence to support that President Monroe, or any U.S. president for that matter, ever chose to take ownership of the cemetery. But that didn't stop Wilson from beginning construction on a wall around his cemetery in 1838.

This was to be no ordinary wall. Wilson designed the wall to form the shape of a dodecagon, with a stone arch, complete with an iron gate, to be used to form the entryway. Each of the twelve sides was to be almost twelve feet in length, making for an impressive wall, indeed.

To form the wall, Wilson had sandstone blocks, each about eighteen inches thick, carved from a nearby quarry and brought to the site—that is, after each stone was cut and shaped at the quarry. According to legend, this was because Nathaniel didn't want to make any noise at the cemetery that could possibly disturb the dead. Whether this is true or not, each individual stone was shaped and carved with angles, allowing them to fit together perfectly without the need for mortar.

Concerning the layout of the cemetery itself, Wilson had that covered, too. He had sketched exactly where each grave, including his own, should go, right down to which direction they should face. And right in the middle of the cemetery, he wanted to plant a Lebanon cedar tree, which he would later import from the Middle East.

Sadly, Nathaniel Wilson III did not see his dreams completed. He died suddenly on May 12, 1839, before the stone wall around the cemetery was completed. The wall's completion fell to Nathaniel's son Gustin, who completed it later that year, using specific instructions left behind in Nathaniel's will.

One of the last things Gustin put in place was a half-moon-shaped piece of stone over the archway leading into the cemetery. On this stone is carved the history of the wall and who built it. The stone reads:

THIS WALL

which encloses the family burying ground of NATHANIEL WILSON (one of the early Pioneers of the West who emigrated from Cumberland County Pa and settled near this place A.D. 1798 when all around was one continued uninhabited wilderness) was commenced by him A.D. 1838 & finished in the following year by his son GUSTIN the former having suddenly died May 12 1839.

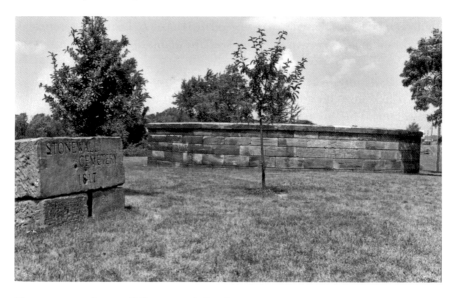

The entrance to Stonewall Cemetery. *Author photo.*

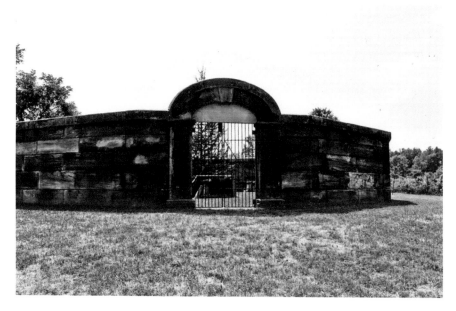

Stonewall Cemetery, complete with its own stone name marker. *Author photo.*

Gustin Wilson died in 1882. Oddly enough, he is not buried at Stonewall Cemetery. He is instead interred at Forest Rose Cemetery in Lancaster, next to his wife. As mentioned earlier, the cemetery's creator, Nathaniel Wilson III, is here, along with other members of his family, including his father, Nathaniel Wilson II, who was relocated to the cemetery in 1907. But not a single president of the United States ever made the decision to be buried here.

Stories exist that, as each president after James Monroe took office, they were officially notified that they were now the proud owners of a cemetery in Ohio. But there are no records to suggest that any president ever visited it. And they certainly didn't send anyone to help with the upkeep of the cemetery. That responsibility fell to descendants of the Wilson family. But as more and more of them moved away or passed on, Stonewall Cemetery sort of sat by itself, all alone by the side of the road, which, by this time, had been renamed Stonewall Cemetery Road.

By the 1960s, it would appear that the presidents of the United States gave up their collective ownership of the cemetery, which was transferred to Fairfield County, the county in which the cemetery resides. Shortly thereafter, the Fairfield Heritage Association took control of the cemetery and began restoring it. Incredibly, while some of the individual grave markers had

toppled and fell victims to the elements, the wall itself was in remarkable condition. There were few cracks and very little settling; the vast majority of the stones used for the wall were essentially where Nathaniel and Gustin Wilson had placed them over 120 years before.

The association was so impressed with what it saw within the Stonewall Cemetery that in the 1970s, its members decided to open up the cemetery gates and share it with the general public. As a reminder that, even then, small groups of idiots tended to ruin things for everyone else, the cemetery was heavily vandalized by those who, for reasons known only to themselves, felt the need to topple tombstones. The Stonewall Cemetery gates didn't stay open for long. They were once again locked up and remain so to this day.

Today, the site is maintained by the Fairfield County Historical Parks Commission, which is responsible for the upkeep of the cemetery and the wall itself. The commission has even ordered and planted a replacement Lebanon cedar tree in the cemetery after the original one was struck by lightning. As for the wall, there's very little the parks commission needs to do with its upkeep. Nathaniel and Gustin clearly knew what they were doing. Don't believe me? Next time you're driving through Lancaster, Ohio, take a detour onto Stonewall Cemetery Road and see for yourself!

PART V

CREATURES GREAT AND SMALL

TALES OF BIGFOOT AND GRASSMAN

Even if you don't believe in his (or her) existence, chances are you're familiar with the legend of Bigfoot—a giant, hairy beast lumbering through the woods, leaving behind giant footprints, all while managing to elude anyone who knows how to take a non-blurry photo or hold steady a video camera. Typically, when an image of Bigfoot springs to mind, the backdrop is the forests of the Pacific Northwest or somewhere equally lush, green and dense. But, Ohio? Not so much. That is why most people are surprised to learn that, year after year, the Buckeye State consistently ranks near the top of the list for reported Bigfoot sightings. In addition, Central Ohio is said to be home to what may be a unique species of Bigfoot, a creature known as the Ohio Grassman.

Before we get to the Grassman, we need to take a look at the different names Ohioans use for the giant, hairy friend. Simply put, while newspaper reports of an enormous hairy creature walking around Ohio on two legs date back almost 150 years, Bigfoot sightings only go back to the late 1950s. The simple reason for this is that the term *Bigfoot* had not yet been associated with the creature. Prior to the 1950s, the creature was referred to as "Sasquatch" or simply "wild man."

All that changed in 1958. Jerry Crew, a construction worker helping on the creation of Bluff Creek Road in California, was preparing to start his day at the isolated, wooded site when he noticed multiple giant footprints around his work vehicle. The prints looked like those of a human walking barefoot, save for the fact that they were huge—sixteen inches long.

Plaster casts were made of the footprints. A local newspaper, the *Humboldt Standard*, ran pictures of the casts, referring to them as being made by a "Bigfoot." Even though the cartoon the newspaper ran alongside the photo of the foot cast looked more like a caveman, complete with club, than the traditional image of Bigfoot we're familiar with, the name stuck. Years later, when claims began to surface that the Bluff Creek prints were a hoax, serious researchers began to shy away from the term *Bigfoot* and reverted to using terms like *Sasquatch* and *wild man* to describe the creature.

Whatever people call it, the question remains: Why would it choose to make Ohio its home? A closer look at the statistics shatters the misconception that Ohio is "nothing but cornfields," revealing a landscape that is more than capable of supporting (and hiding) creatures such as Bigfoot. A 2009 report by the forestry division of the Ohio Department of Natural Resources stated that 31 percent of Ohio is forested and that there are 8.1 million acres in tree cover. Salt Fort State Park, Ohio's largest state park and home to numerous Bigfoot sightings, comprises nearly 17,230 acres. Data from the 2010 U.S. Census found that almost 4,000 acres, or 8.8 percent of the entire state of Ohio, was covered by water. There are plenty of places for a Bigfoot to hide, eat, sleep and drink.

So, what are Ohioans, particularly those in Central Ohio, really seeing? As noted earlier, the first documented encounters with what people today would call a Bigfoot simply reported the presence of "wild men." The first known reference to a wild man in Ohio appeared in a newspaper article in January 1869. According to the article, a father and daughter were traveling in their horse and buggy when they were attacked by a wild man. The father was locked in what appeared to be a life-or-death struggle when the daughter struck the creature with a rock, sending it running off into the woods.

The creature was described as being "gigantic in height" and covered in hair. It's interesting to note that multiple references in the article imply that the creature may have been human, including a mention that the creature was "naked"—certainly not a term one would use to refer to an animal. There is also no reference to giant feet or footprints.

In the 1920s, the term *Sasquatch* was coined, credited to Canadian journalist J.W. Burns. Burns was researching the various "hairy giants" that were being reported throughout British Columbia by native Canadian tribes. In an effort to come up with a single name to refer to all the sightings, Burns decided to combine several Native Canadian words to create a new one: Sasquatch. The term stuck and spread throughout British Columbia and, eventually, the United States.

In Ohio, "Sasquatch" began being used in place of "wild man." However, unlike the wild man encounters, ones with Sasquatch clearly involved a nonhuman creature that was more ape-like in appearance. It had grown, too, and was now often reported as being between seven and eight feet in height. There were still no footprints, though. Those would come as a result of the aforementioned 1958 Bluff Creek episode. Almost immediately after Bluff Creek, Ohioans started finding giant footprints in the woods and even in their own backyards. Of course, as in the rest of the nation, when people started calling the Bluff Creek incident a hoax, Ohioans began to shy away from the term *Bigfoot*. Some reverted to saying "Sasquatch," while others simply called it a "beast" or "monster." Of course, Ohioans like being different, so they also made up new terms and monikers to describe what they had seen. A case in point is 1978's Minerva Monster.

Minerva is a small Ohio village spread out over Carroll, Columbiana and Stark Counties. One night in August 1978, members of the Cayton family were sitting together in their house when they heard a commotion outside. They would later claim to have seen some sort of creature, covered in hair and standing on two feet, near the woods surrounding their home, looking at them. After a period of time, the creature disappeared into the woods. This would be the family's first encounter, but it would not be the last. The Caytons reported that days later the creature came right up to their house and looked in the windows at them. Since it was so close, they were able to give a better description of the creature: six feet tall, brown and black hair covering its entire body, including its face, and weighing three hundred pounds. Oh, and it smelled like rotten eggs.

The Caytons reported their encounter to the local police. They never mentioned the word "Bigfoot," but when the story was picked up by the local newspaper, that's exactly what everyone thought the creature was. It didn't take long for the Cayton house and surrounding woods to be overrun with people carrying cameras, guns and, in some cases, six packs of beer, trying to capture the creature dubbed the "Minerva Monster." Despite everyone's efforts, while there were a few more sightings of the beast, no concrete evidence was ever found. It was as if the Minerva Monster had simply vanished. Or, maybe, it had simply moved a bit south to Salt Fork State Park; beginning in the 1980s, there were numerous reports of a giant, hairy, Bigfoot-like creature roaming the park's many acres. So many encounters were reported that the park was often referred to as "Ground Zero" for Bigfoot sightings. On top of that, in recent years, researchers began referring to what may actually be a new species of Bigfoot: the Grassman.

Cast of an alleged Grassman footprint, recovered by cryptid researcher Joedy Cook. *Author's collection.*

Beginning in the early 2000s, Bigfoot researchers started throwing around the term *Grassman*. For most, the Ohio Grassman was simply a Bigfoot who had acquired its name because it was first spotted while standing in tall grass many years ago. Others claimed Grassman was an entirely different creature. Then came the reality television shows, and things really got confusing.

On June 18, 2008, an episode of *Monster Quest* focused exclusively on the Ohio Grassman. While the show made it appear that the creature was different from Bigfoot, its description of Grassman was strikingly similar: seven to eight feet tall, broad shoulders and muscular build, large hands and feet, upright posture and with black or brownish hair. The distinctions between Bigfoot and Grassman are not explained in great detail, although the show did spend time focusing on a nest-like shelter discovered by cryptozoologist Joedy Cook that was attributed to having been created by a Grassman.

Further complicating things is *Mountain Monsters*, a reality TV show that has come under fire regarding just how "real" it is. According to the episode "Grassman of Perry County," which first aired in June 2013, Grassman is "larger than its cousin, the Sasquatch" and weighs in at one thousand pounds while standing eight to nine feet tall. *Mountain Monsters* has apparently become infatuated with Grassman; over the course of four seasons, it has aired three episodes focusing solely on Grassman, each with exclusive videos allegedly showing the mysterious cryptid. Of course, the fact that, in a 2016 episode, one of the monster hunters claimed to have gotten a concussion when he was smacked in the face by a Grassman suggests that anything associated with this show should be taken with a healthy dose of salt.

However, *Mountain Monsters* having devoted three recent episodes to Grassman is a clear indication that interest in Bigfoot and Bigfoot-

Even without concrete proof of their existence, Grassman and Bigfoot have certainly brought notoriety (and tourism) to the area. *Author's collection.*

like creatures in Ohio is at an all-time high, with no sign of lessening. Certainly, the allure of catching a glimpse of a legendary creature and proving its existence plays a big factor, too. So, if you should find yourself near Salt Fork State Park with some time to kill, strap on your hiking shoes and give it a shot. Sure, the only "evidence" you come back with may have been purchased in the park's gift shop, but just think of the stories you'll have to tell.

THE LITTLE PEOPLE OF COSHOCTON

Pygmy is the term given to a member of an ethnic group in which adult male members are on average under five feet tall. This term, as well as *pygmies*, is most often associated with tribes of hunters and gatherers in central Africa, especially those in the African rain forests. They are a mysterious group, to be sure. In fact, while there are many different pygmy tribes throughout central Africa, each has its own distinct dialect and language, leading to some confusion as to their origins. Some researchers believe all pygmies originated from a single group that was scattered when outsiders began pushing farther and farther into the rain forest. Others maintain that they have always been distinct tribes.

Whatever the case may be, the one trait all pygmies share is their short stature, although, again, how or why most adult males do not reach a height of five feet is something that leaves many people scratching their heads. Most, however, believe the rain forest has something to do with it: the low ultraviolet levels in the rainforest not allowing their bodies to make sufficient vitamin D for bone health, or the rain forest not providing sufficient food sources. As evidence for the role of the terrain, researchers point to the fact that very few pygmies are reported living far from a rain forest. That is, unless one believes the legend of a graveyard containing the bodies of an entire race of ancient pygmies unearthed near Coshocton, Ohio, in the 1800s.

According to historical texts, the first person to become attached to this legend was David Zeisberger, an eighteenth-century Moravian missionary

who worked extensively with Native American tribes in Ohio. *The Centennial History of Coshocton County, Ohio, Volume 1* states that while in the Coshocton area, Zeisberger "noted the numerous signs of an ancient race here. He referred particularly to the cemetery containing thousands of graves near the mound three miles south of Coshocton."

That's right, thousands of graves. There are a couple of other things to note here. First, Zeisberger does not use the term *pygmy* or any other description to suggest that the bodies inside the graves were of short stature. Second, there is the mention of a "mound" located near the cemetery. Zeisberger is in fact referring to an ancient burial mound. This came into play years later, when researchers tried to draw a correlation between the cemetery and the mound.

As for who was the first to find the graves, that discovery is usually credited to a man known as J.C. Milligan. However, most reports describing the contents of the cemetery originate from the accounts of Samuel Prescott Hildreth.

Hildreth was an interesting character. He was an incredibly intelligent man who was both a physician and a scientist. He also considered himself an author and was somewhat obsessed with chronicling the lives of the early pioneers. Indeed, he wrote several books on that very subject, most of which were filled with first-person accounts of what Hildreth encountered as he traveled to and spent time at pioneer settlements, including many in Ohio.

Taking all this into consideration, one could safely describe Hildreth as being very down to earth, not someone prone to flights of fancy. This makes the descriptions of what he claimed were inside the graves all the more fascinating.

Published in an 1835 edition of *Stillman's Journal*, Hildreth's description of the skeletal remains is as follows:

> *The bodies seem all to have been deposited in coffins; and what is still more curious is the fact that the bodies buried here were generally not more than from three to four and a half feet in length. They are very numerous, and must have been tenants of a considerable city, or their numbers could not have been so great. A large number of graves have been opened, the inmates of which are all of this pygmy race.*

Hildreth based his assumption that the bodies had been placed in coffins on the observation that some of the remains had pieces of "rotting wood" around them. Later reports would change the "rotting wood" to "oak

boards" and add "iron wrought nails" to the mix, something Hildreth did not initially note.

How many graves were there, exactly? That's hard to say. Hildreth's initial description only states that the graves were "very numerous," which could mean almost anything. The number would continue to grow over time.

The May 3, 1931 edition of the *Coshocton Tribune* further muddied the waters by proclaiming, "About two miles south of Coshocton, there is a cemetery of pygmies which it is estimated contains about thirty thousand graves."

Likewise, the overall size of the cemetery grew. Today, there are claims that the cemetery covered almost a full ten acres. Of course, it is almost impossible to determine its true size today because, in the name of progress, the "cemetery" was plowed under shortly after its discovery. By 1975, all that remained was the mound located along the southern edge of what was once the cemetery. The cemetery itself had been obliterated.

What happened to all the bodies? You would think that a discovery of this magnitude would have brought researchers from all over, resulting in more than a few bones and assorted relics making their way to local museums. Well, if you thought that, you'd be wrong. There are no records showing what happened to anything removed from the cemetery grounds. What's more, there is very little evidence to suggest that there were even any attempts to remove or study the remains.

The May 31, 1931 edition of the *Coshocton Tribune* adds an interesting wrinkle to the story, naming at least one individual who was involved with an excavation of the cemetery. However, it is not specifically stated if he was doing it as part of authorized research or out of morbid curiosity. Regardless, the newspaper says a Coshocton resident by the name of James Preston removed some of the bones from the mass grave and "altho [*sic*] they were a dark brown color when dug up, contact with the air quickly turned them to a gray ash." If true, this could mean that any bones removed from the graves disintegrated before they could be studied, thus explaining the absence of any bones known to have come from this mass burial site.

Were these really the skeletal remains of an ancient tribe of pygmies? Your guess is as good as mine. We do know that Hildreth believed they were. But if we are to accept that they really were pygmies, that would mean there should be more evidence of such a group existing in the area—but there is not. Simply put, other than the cemetery itself, there is no other evidence to suggest that pygmies were ever in the United States, let alone in Ohio.

The front page of the Saturday, March 22, 1924 issue of the *Coshocton Tribune* may shed some light on all of this. Under the lengthy headline

"Mystery Surrounds Burial Ground at Rock Run: Skeletons Short in Stature—May Be Cemetery of Pygmies, Is Belief" is an in-depth article that appears to explain some of the history behind the site and what was recovered there.

The article references a "Lucy Roof, of the county historical class" who provided the newspaper "a story from research work on this phase of Coshocton County history." The article continues that, while some people truly believed that these were graves of pygmies, others had a more mundane explanation. Namely, that the graves belonged to an unknown nomadic "tribe of Indians" who had adopted the custom of bringing their dead with them when they migrated to a new area. In other words, before leaving, they would dig up the remains of their dead, bring them to the new location and re-bury them. If true, the skeletons' apparent short stature could be due to nothing more than that they were incomplete, as their relatives had inadvertently left some of the bones behind in the previous grave.

There is yet another theory, albeit a rather bizarre one, put forth by the article. Namely, that the graves belonged to a tribe that, for whatever reason, chose to cut off the legs of the deceased before burying them. This theory had apparently gained some traction, as the *Evening News* of Wilkes-Barre, Pennsylvania, ran an article in its April 18 edition with the headline "Indians Were Pygmies or Else Cut Off Legs." Referencing an "opinion voiced by members of the Coshocton high school historical class," the article stated those believed to be pygmies may have been, in fact, Indians who "observed a custom of cutting off the legs of their dead at the knee for the purpose of deceiving as to height." The reason for such a custom is never addressed by the article, nor is the reason the group reached such a bizarre conclusion.

Where did the idea that these skeletal remains were pygmies come from, especially since there had been no documented case of pygmies living in the United States? One answer may lie in the fact that at the time of the initial discovery, newspapers across the world were sharing exciting accounts of explorers trekking deep into the rain forests of Africa and meeting tribes of pygmies. So, perhaps people had a case of "pygmies on the brain"; on finding what appeared to be a mass burial of short people, they immediately thought of pygmies.

One final theory is that the skeletal remains weren't pygmies or even adults. Rather, they were simply the skeletal remains of children. In other words, what was discovered was nothing more than a children's cemetery. That's certainly plausible, but it does make one wonder where the children's parents ended up. Even if one posited the theory that several thousand children were

wiped out by some sort of ancient plague or epidemic, one would think there would be some signs nearby of adults. Yet, there is no mention of a single person over five feet tall being discovered in and around the area where the graves were found.

In the end, we are left with very few answers. All of this begs the question: What really was discovered out in that field just outside of Coshocton? More important, where do those discoveries reside today?

ROARING THROUGH GAHANNA

As someone who recently moved from the suburbs of Columbus to a more rural setting, I can tell you that, out here, all sorts of critters dart in front of your car. The most interesting are the "country deer," which basically stand in the middle of the road and glare at you, as if saying, "Hey! I'm walking here!" I've caught all kinds of animals in my headlights, but I can honestly say that I've yet to see a lion. Yet that's exactly what allegedly happened in the Columbus suburb of Gahanna, Ohio, in 2004.

On Monday, May 3, 2004, when residents began calling authorities and reporting that they had seen a lion roaming through their neighborhood, the Gahanna Police Department was skeptical, to say the least. But private citizens weren't the only ones calling in sightings. One of the initial reports was from a police officer, who was stopped on a street when the lion "bounded across the pavement" in front of the police car. So many reports started coming in that local television helicopters took to the air and began circling over the city limits, attempting to catch sight of the lion. Gahanna police even reached out to the Columbus Zoo to see if one of its lions was missing. When told they were all accounted for, police then turned to the zoo for advice on what should be done if, and when, a lion was located.

Once the media got hold of the story, the obvious question was raised: Couldn't this be something other than a lion? After all, how does a lion end up in Central Ohio? Local police, however, held fast to their belief that the creature was in fact a lion—a big one, at that. Deputy Police Chief

Welcome to Gahanna. Mind the lions, please. *Author photo.*

Larry Rinehart was even quoted by CBS News as saying that he was "convinced it's a 300-pound to 400-pound African lion."

Things really got exciting when a group of individuals sent out to search for the lion radioed in that they had it cornered. A police helicopter was quickly dispatched to the scene and circled overhead as the team inched closer. Supposedly, members of the Columbus Zoo were there at the ready, tranquilizer guns in hand. It all came to naught—it was only a coyote.

Over the course of the next few days, reports of sightings continued to come in, and the helicopters kept flying overhead. Police fielded calls and advised residents to keep their garage doors closed and maintain a close eye on their children. But nothing ever came of the entire lion situation. Not a single photograph, video or even a muddy track turned up to validate the presence of a lion in the area.

People had all but given up on the Gahanna Lion. Then, on July 8, Madison Township fireman Ed Dildin was out on a training run in the city of Canal Winchester with several fellow firemen. As his fire truck was passing a rather large cornfield, Dildin said he saw a lion poking his head out from between the rows of corn. Dildin described the animal as being "about 200 pounds and blonde, with a long tail." He said there was "no doubt" in his mind that what he saw was a lion. None of the men in the truck with Didlin reported seeing the lion, or any other animal for that matter. Still, Didlin's alleged sighting was enough to make some believe that the Gahanna Lion had migrated the dozen or so miles southeast from where it was originally sighted to where Dildin had his encounter. Those who subscribed to that theory pointed out that Backlick Creek runs between Gahanna and Canal Winchester; the lion could have easily followed the creek.

After the Dildin sightings, reports started to taper off again. A few random phone calls came in to the local police, but despite all attempts to capture or even get a photo or video of the alleged lion, the creature remained elusive. All that changed, however, on the night of November 3 in Granville, Ohio, thirty-five miles east of Columbus.

That evening, Granville Police received a report of "a lion in a field" near the intersection of Cherry Valley and Newark-Granville Roads. They dispatched Officer Suzie Dawson to the scene. On her arrival, she, too, noticed what appeared to be a lion in the field. As she kept her eyes on the animal, she radioed for backup. When a second officer arrived on the scene, he saw exactly what Dawson did: a large cat lying in the field. Before they could get close enough to make a positive identification, the creature rose up and bounded off into the field, disappearing from view.

The following day, Granville police chief Steve Cartnal went out to where the two officers had reported seeing the lion. Nearby, Cartnal found a half-eaten deer carcass. At that point, he decided he needed to take these lion sightings seriously and issued a letter to local residents stating, in effect, that the stories of a lion in the area are to be taken seriously and that the officers involved "would not joke about this and are totally serious about what they saw."

As soon as the police chief issued the letter, more reported sightings came in. According to what people were saying, the lion was roaming through fields and, in some cases, subdivisions. Some concerned residents decided to try to trap the lion themselves. The county even went so far as to put out deer carcasses to lure the elusive beast. This only resulted in making the local turkey vultures very happy. Not a single lion showed up to this impromptu deer buffet.

Several weeks later, all of Ohio had turned its attention from lions to turkeys; by the time Thanksgiving was over, so were the reports of a lion running loose. There has not been a major sighting since then.

What, if anything, were these people seeing? If it really was a lion, it obviously came from somewhere. At the time, the state of Ohio did allow residents to own exotic animals, including lions, provided they registered them with the state. Records were checked and owners were contacted, but no one reported a missing lion. All of the lions at the Columbus Zoo were accounted for, as well. The popular belief was that people were actually seeing a mountain lion. While the animal was certainly not indigenous to Ohio, it could survive in the area.

Of course, there are those who think that people were just freaking out over nothing or making the whole thing up. Some even say it was a practical joke that got out of hand, resulting in a kind of mass hysteria. That may seem a bit far-fetched, but consider this: The local high school in Gahanna, Ohio, where the sightings began, is named Lincoln High School (formerly Gahanna High School). The official mascot for Lincoln High School is…a lion. A golden lion, to be specific.

PROJECT BLUE BOOK

Aliens. Flying saucers. Little green men abducting us in our sleep. Throw all these legends and stories together, and they can add up to one big ol' conspiracy. Namely, that the U.S. government is well aware that aliens and their crafts exist but is keeping the truth from us. Of course, if that were true, why would the U.S. military engage in a decades-long study to see if the existence of alien crafts could be proven? The government did undertake such a study. And guess what? That study originated in Central Ohio.

When it comes to a study of flying objects, few could think of a better place for its headquarters than Wright Field. Originally constructed in 1917 to train personnel for World War I, the facility had grown considerably over the years and, by 1947, was just a year away from combining with nearby Patterson Field to become Wright-Patterson Air Force Base.

It was also in 1947 that the air force decided to create a program to investigate reports of flying saucers to determine if they were a threat to the nation. Project Sign was created to do just that, but infighting about how the project should be run and the direction it should take brought about its closure within the year. It was replaced with Project Grudge in 1949, but that, too, ended within a year, although it did linger in some form until late 1951.

Even with the failure of these two projects, there was still pressure to create a group to investigate flying saucers. In order to do that, though, officials needed to determine why previous projects had failed. When reviewing both Sign and Grudge, they realized that many of the people involved weren't

taking the projects seriously. In order to get things off to a serious start, the project was named Blue Book, after the blue books that college students use for final exams. Officials wanted the people working on the project to treat their work as seriously as a final exam.

Next, they needed someone who could streamline the systems they were trying to put in place. Reports were coming in from all over the United States. With that in mind, the air force tapped Captain Edward J. Ruppelt to head up Project Blue Book. Ruppelt had been involved with Project Grudge and was looked upon as someone who was very organized and thorough.

When Project Blue Book was officially announced in 1951, it was with two distinct goals in mind. First, to be a storehouse of sorts in order to scientifically analyze data concerning these sightings. Second, and perhaps most important to the military, it was to determine if these reported crafts represented a threat to national security.

Captain Ruppelt began by working to create a natural flow of information through the Project Blue Book offices. Essentially, if anyone reported seeing something strange in the sky, and if that report made its way to an air force base anywhere in the United States, the report was immediately forwarded to Project Blue Book. After the Blue Book staff reviewed the report, they would follow up with a phone call and/or a detailed questionnaire. If the case warranted it, Blue Book team members could visit the location of the sighting themselves and interview witnesses. The goal was to either find a rational explanation for the sighting or label it "unexplained."

By all accounts, Captain Ruppelt initially enjoyed his work on Project Blue Book. He was genuinely interested in the subject and is even credited with coining the terms *Unidentified Flying Objects* and *UFO* to better categorize what people in some of the reports were seeing. In other words, not everything people were reporting was shaped like a flying saucer. Years later, Ruppelt would hint at his displeasure that perhaps his bosses weren't as enthusiastic about the project and didn't take it seriously. As evidence of this, when Ruppelt was called away from Project Blue Book on temporary reassignment, he returned to find that his staff had been reduced significantly. Realizing things were only going to get worse, Ruppelt requested reassignment.

In March 1954, Ruppelt was reassigned and replaced by Captain Charles Hardin. Unlike Ruppelt, Hardin was not as open-minded when it came to the idea of UFOs. In fact, Ruppelt himself would go so far as to say that Hardin felt anyone who was interested in UFOs was "crazy."

Under Hardin, the number of UFO reports coming into Project Blue Book offices increased; the program was taking in thousands of reports a year.

This was deemed to be too much; for whatever reason, in 1955, the air force switched Project Blue Book's main focus from investigating UFO reports to simply finding a way to minimize the number of reports coming in.

Captain George T. Gregory replaced Hardin in 1956. If possible, Gregory was even less of a believer than Hardin. As a result, more Project Blue Book employees began to lose interest. It didn't help that, around this time, an organization calling itself the National Investigations Committee on Aerial Phenomena (NICAP) was formed and began accusing the air force of using Project Blue Book to cover up the truth about flying saucers.

In 1958, Major Robert J. Friend was brought in to turn things around within Project Blue Book. He not only attempted to open up the lines of communication regarding new sightings, but he also worked with scientific consultants like astronomer Dr. J. Allen Hynek to take a look at older cases still listed as "unexplained." He had several initial successes, but 1960 would be a very trying year for Major Friend and Project Blue Book. That's because NICAP had been putting so much pressure on the air force that congressional hearings were ordered to look into the possibility that Project Blue Book was covering up the truth about UFOs by suppressing the true reports and only entertaining the ones with rational explanations. The hearings found nothing to substantiate those claims, but from that point on, the project was under heavy scrutiny from both Congress and NICAP.

In 1963, Major Hector A. Quintanilla Jr. took over as head of Project Blue Book. Skeptics of the project were now openly accusing the team of not taking things seriously, seeking only to debunk UFO reports as opposed to thoroughly looking into them. When questioned about these claims, Major Quintanilla denied them, stating, "If a citizen is going to take the time and pains to report a sighting, it is our duty to take time and pains to find out more about it."

Three years later, in 1966, the air force provided a $313,000 grant to the University of Colorado for an independent study of UFOs. Specifically, it wanted a group of scientists to take a closer look at all the UFO reports from Project Blue Book to see if any additional insights could be gained from them. Dr. Edward Condon, a physicist and professor, was chosen to head up the group, which would be renamed the Condon Committee. The committee conducted its research over the course of the next two years, officially filing its findings with the U.S. Air Force in November 1968.

The Condon Report, as the team's findings became known, was officially released in January 1969. It concluded that, after reviewing over twenty years' worth of UFO reports, none of them added any "scientific knowledge."

The report also concluded that "further extensive study of UFOs probably cannot be justified in the expectation that science will be advanced thereby." Needless to say, the Condon Report signaled the end of Project Blue Book, which ceased operation in December 1969. By January 1970, offices had been dismantled and miles of reports filed away or disposed of.

Of course, before Project Blue Book vanished completely, its staff did need to file an official summary of their findings. After reviewing over 12,600 reports since its inception, the conclusions reached by Project Blue Book were as follows:

- *No UFO reported, investigated and evaluated by the Air Force was ever an indication of threat to our national security.*
- *There was no evidence submitted to or discovered by the Air Force that sightings categorized as "unidentified" represented technological developments or principles beyond the range of modern scientific knowledge.*
- *There was no evidence indicating that sightings categorized as "unidentified" were extraterrestrial vehicles.*

The vast majority of the reports, Project Blue Book concluded, were simply misidentifications of natural objects. The project did admit, though, that a "small portion" of the reports remained "unexplained."

If eyewitnesses really weren't seeing alien spaceships, what were they looking at? According to the official report from Project Blue Book, the most likely culprits included, in alphabetical order:

- *Airplanes*
- *Birds*
- *Clouds*
- *Meteors*
- *Mirages*
- *Planets*
- *Reflections*
- *Satellites*
- *Searchlights*
- *Sparking electrical wires*
- *Stars*
- *Swamp gas*
- *Weather and sounding balloons*

The U.S. Air Force has repeatedly stated that, based on the findings of Project Blue Book, there is no need for continued research and there are no plans to resurrect the project or anything like it. Conspiracy theorists everywhere, though, still claim that Project Blue Book was nothing but a smokescreen for the general public while providing a convenient way for the government to snatch up evidence of UFO sightings and crashes under the guise of research. This evidence, skeptics believe, is still there, hidden away in the bowels of Wright-Patt Air Force Base.

PART VI

URBAN LEGENDS

ENTERING CLINTONVILLE'S
GATES OF HELL

For centuries, people around the world have whispered that certain locations contain hidden entrances to the underworld. These were places best avoided, for passing through one of these foreboding gates would set you on a direct path to hell on what many consider a one-way trip. In most cases, these mysterious gates are located in far-flung, exotic locations, like deep within a cave in Belize or inside a volcano in Nicaragua. And there's the alleged entrance to hell located behind the Tim Hortons restaurant in Clintonville.

While this location has been known as the Gates of Hell for many years, things weren't always so hellish. In fact, the area is nothing more than a drainage culvert that diverted a small runoff stream into a tunnel that runs under North High Street. When originally installed, sloped concrete walls were poured along the eastern side of the culvert to help with drainage and prevent erosion. These walls were perfect for local skateboarders, and it didn't take long for them to discover the place and claim it for their very own. Of course, given how tall and steep the walls were, more than a few skateboarders ended up face-planting into the concrete, which may be where the location's nickname, the "Blood Bowl," came from.

Unsubstantiated stories claim that Blood Bowl was born out of something more serious than skinned knees and bloody noses. In fact, it is whispered that more than a few skateboarders lost their lives here when the tricks they were performing went horribly wrong. In some instances,

Standing just inside the Gates of Hell, taking one last look back. *Author photo.*

the kids are on **BMX** bikes as opposed to skateboards, but the tragic results are the same. There are even versions in which young daredevils have attempted to ride their skateboards (or bikes) through the tunnel itself. As if attempting to travel through a tunnel in the dark wasn't hard enough, the passageway under High Street has several ninety-degree turns designed to regulate the flow of water. Even if one were aware of these turns, it would be nearly impossible to navigate them at full speed in the dark. Naturally, in these stories, those who choose to ride into the tunnel don't make it back out alive.

The location received a new name when a series of metal structures was erected to help keep debris from entering the tunnel under High Street. This was necessary because, while the small stream was practically dry most of the time, the slightest rainfall could produce flash flood conditions, which would bring all sorts of debris—from tree limbs to garbage—rushing down toward the tunnel under North High Street. As part of a plan to stop the debris from getting into the tunnel, several giant metal partitions were

erected along the stream's path. The fronts of these partitions came to a point, with the sides gradually sloping outward. The idea was that, as debris came downstream, it would hit the point of the partition and then be pushed outward to the shoreline, thereby allowing the water itself to continue to flow freely. The partition immediately in front of the tunnel's east end was positioned in such a way that it extended from each side of the tunnel's opening, coming to a point farther upstream. From afar, the image is that of an old, rotting hull of a ship emerging from the tunnel.

The Gates of Hell were officially born.

It's interesting to note that while there are indeed several "gates" farther upstream, when someone refers to the Gates of Hell, they are referring to the single structure located in front of the eastern entrance to the tunnel. The reason for this may be that, as seen from the front, the two sides of it come together to form the shape of a "V" in the middle of the stream. Well, almost come together. There is a small gap between the two sides just large enough for someone to fit through. Looked at from just the right angle, it can resemble an opening in a gate with the tunnel looming behind it. In reality, it's just the gap for the water to flow through. But under the right conditions, it can look quite menacing.

Some people say that there's more to the story of the Gates of Hell. Namely, that there is an actual porthole to another world hidden away inside the tunnel. Or that strange rituals have been known to take place here late at night. To be honest, I find the latter case hard to believe. If one was looking for a secret place to hide away in order to chat up Beelzebub, this might be the last place on one's list. It's next to a park, and the tunnel has a lot of echo to it. For example, you can hear when someone's in the tunnel from all the way up in the Tim Hortons parking lot. The sound travels that far.

Of course, if you go deep enough into the tunnel, there is some graffiti that could be taken as "satanic." In all probability, it was put there by someone trying to copy what they saw on some of their parents' '80s heavy metal records. Personally, I found the graffiti that proudly proclaimed "Satin rules" to be the most terrifying thing in the tunnel—mainly because I consider myself a cotton blend kind of guy.

As for the stories that there is a secret passageway inside the tunnel, there's absolutely no evidence to support that. The idea of the tunnel extending out and having additional rooms seems to have originated from people entering the tunnel and not understanding why there are several turns as opposed to a straight shot from one side of the road to the other.

View from inside the Gates of Hell, looking outward. *Author photo.*

I'll admit, it does seem a bit odd, until you consider that it was done to control (and slow) the flow of water. But that's it: there is no hidden doorway to hell to be found. However, if the devil really was going to put up an entrance to hell, it's not like he's going to make it easy to find. Think of all the solicitors he'd have to put up with.

The Ohio Players'
Rollercoaster of Death

I have been obsessed with all things strange and spooky since I was a child in upstate New York. Looking back, it never ceases to amaze me how much Ohio-based weirdness came creeping into my life at an early age. It was as if fate was already tipping its hand that my strange journey would eventually lead me to the Buckeye State.

As a case in point, I can distinctly remember Christmas break in 1976, when I had some friends over to hang out and listen to records. I was all about my new *A Day at the Races* album by Queen, but one friend insisted I put on one of his records. But it was a disco record, and as far as I was concerned, disco was of the devil. Still, he was insistent, and he knew just how to get my attention: "But James, check this out. You'll like this. If you listen to this one song, you can hear a woman screaming in the background. Know why she's screaming? My brother says it's because the woman's getting murdered in real life!"

Needless to say, the record immediately went onto my turntable, and we all huddled around, listening for the woman's death screams.

I know what you're thinking: There's no way the screams of a woman being murdered "in real life" would ever find their way onto a finished recording. Who would believe such a story? Well, to be honest, I did at first. And I wasn't alone. Truth be told, in the late 1970s, thousands of people believed they could hear the sounds of a woman being murdered at the beginning of the Ohio Players' song "Love Rollercoaster."

Based out of Dayton, the Ohio Players released their *Honey* LP in late 1975. One of the first singles from that album, "Love Rollercoaster," immediately started climbing the charts. Not long after, people began whispering about the strange woman's screaming that could be heard early in the song. Who was this woman, and why was she screaming? Well, those questions were rather hard to answer, especially since there are several different versions of the tale.

In one version, while the Ohio Players were recording "Love Rollercoaster," an unknown woman was actually being murdered and her screams somehow managed to bleed (no pun intended) through the studio walls and onto the recording. In a slight variation to this version, one of the studio's engineers records the murder and then mixes it into the song without the band knowing it. Oh, and then there's the version that says it's not a woman who is being killed—it's a rabbit. Yes, a rabbit.

Regardless, it's hard to take any of these variations seriously, as it seems nearly impossible for a sound to bleed through studio walls and onto a recording without being initially noticed, especially given the fact that most artists wear headphones while they are recording. As for the engineer mixing the screams in, you would have thought that some of the Ohio Players would have heard the screams during playback and questioned where it came from.

This brings us to another version of the legend. In this tale, the Ohio Players were aware that the woman's screams were real. She's not being murdered, though. In fact, she's falling off a rollercoaster to her death. Once they heard where the recording came from, the Ohio Players felt it was an interesting, albeit morbid, recording and added it to the final mix.

We aren't done yet. There are two final variations of the legend, both involving Esther Cordet, the model who appears on the *Honey* cover, the album containing "Love Rollercoaster."

Honey had no ordinary album cover, although it certainly does reflect the time in which it was produced. On the cover, Cordet appears nude, holding an oversized jar of honey in one hand and using a ladle to pour honey into her open mouth. The album was a gatefold, which featured a second nude photo of Cordet. In this photo, her body was now completely covered in honey. According to legend, it was during the photo session for the gatefold pic that the photographer's lights became so hot that they heated the honey to the point where it practically cooked onto Cordet's skin. The result was that she was horribly scarred over most of her body. Realizing that her modeling career was, in effect, over, Cordet sunk into a deep depression,

Cover of the Ohio Players' *Honey* album, featuring model Esther Cordet, one of the alleged sources of the screams on the song "Love Rollercoaster." *Author's collection*.

which soon turned into a blind rage. When Cordet heard that the Ohio Players were in a local studio, she decided to pay them a little visit.

The tale goes on to say that when Cordet burst into the studio, the band was just starting to record "Love Rollercoaster." Cordet attempted to get at the band, at which point she was grabbed by the group's manager. A struggle ensued, resulting in Cordet being stabbed and killed. The screams heard at the beginning of the song are from Cordet being fatally stabbed.

The last version of the legend involving Cordet is a slight variation on the "album photo shoot" story. This version takes place entirely in the photographer's studio; the screams are from Cordet as the honey burns her

body. One has to wonder, though, why anyone would be running audio at a photo shoot.

Regardless of which version of the Cordet-focused legend one wishes to subscribe to, a quick online search can put all the variations involving Ester Cordet to rest. As of this writing, Cordet is alive and well and apparently devoid of any honey-induced scars.

What do the Ohio Players have to say about the whole thing? Interestingly enough, the band has always maintained that the screaming woman was actually a man: keyboardist Billy Beck, to be exact. When asked about the legend shortly after it started making the rounds in the late 1970s, they made no secret that they knew nothing of the legend's origin and were as surprised as anyone when they heard about it. Like everyone else, the band had no idea how the story got started.

The Ohio Players, however, might be at least partly responsible for the legend's continuing life decades after the release of "Love Rollercoaster." It is said that, after initially openly talking about the falseness of the legend, the band decided to simply avoid the question altogether. The reason? Well, let's just say the band thought the story would help boost record sales. True or not, the Ohio Players' *Honey* reached no. 2 on the *Billboard* album chart. As for "Love Rollercoaster," it reached no. 1 on *Billboard*'s Hot 100 chart on January 31, 1976. It would go on to be certified as gold (more than 500,000 copies sold).

Want to hear the screams and decide for yourself? You can hear them between 1:24 and 1:28 on the single version of "Love Rollercoaster" and between 2:32 and 2:36 on the album version of the song.

Slashing Prices (and Patrons) at Central Ohio Malls

It's the stuff urban legends are made of: A young woman leaving a busy mall finds one of her car's tires has gone flat. As she ponders her situation, she is approached by a Good Samaritan carrying a briefcase. Setting down his briefcase, the man quickly changes the woman's tire and places it in her trunk. When he asks for a ride to his car, which he says is located on the other side of the parking lot, the woman grows suspicious. Making up an excuse to go back into the mall, the woman leaves the man and quickly locates mall security, who accompany her back to her car. Upon arrival, all that's left of the man is his briefcase. When security opens the case, they find the only items inside are a knife and some rope. The following day, the tire shop where the woman had dropped off her flat tire called to let her know everything was fine: Someone had simply let all the air out of it.

Stories such as this one have been circulating across the United States for many years. Interestingly enough, versions have been in existence in Europe since the early nineteenth century. Obviously, there weren't cars or shopping malls back then, but most of the other elements of the story are there. In the original version, a woman is walking alone and is approached by what appears to be an older woman, who asks for directions and/or assistance. Something doesn't seem right about the old woman, though. When given the chance, our fearless heroine takes a peek inside granny's bag and is shocked to find it filled with all sorts of weapons and devices designed to either restrain or maim...or both. It is then that something odd is noticed about the old woman (oversized feet,

The Mall at Tuttle Crossing, for all your urban legend needs. *Author photo.*

hairy arms, gruff voice) that leads to the discovery that granny is, in fact, a homicidal maniac in disguise.

The story, which started out as a cautionary tale for young women, has endured through the ages, although, like all good urban legends, it mutated as the years went by. Some of the biggest changes, as noted by Jan Brunvand in his 2001 book *Encyclopedia of Urban Legends*, are that the older woman asks for a ride somewhere and her true identity is almost always revealed when the potential victim notices the large amounts of arm hair. This particular legend became known in the United States as "The Hairy-Armed Hitchhiker."

By the middle of the twentieth century, another change to the urban legend took place: the disguise fell by the wayside. Now, the assailant was a mild-mannered gentleman who showed up in the guise of helping women in mild distress, usually caused by finding they had a flat tire (later determined to have been caused by the man letting the air out of it). The kidnapper's tools are usually discovered inside a briefcase, which he leaves behind while attempting to flee the area.

This is the form of the urban legend that began to spread across the United States beginning in the 1980s. The events described in the story were usually said to have taken place in mall parking lots, where the woman discovers she has a flat tire after a day of shopping. As she struggles to fix her flat tire, she is approached by a strange man carrying a briefcase. For reasons that have never been fully identified, in the late 1990s, a variation of this legend took place at Dublin, Ohio's Mall at Tuttle Crossing. It is almost identical to the story mentioned earlier, right down to the discovery of the homemade kidnapping kit inside the assailant's briefcase.

As with the event in the original urban legend, the Mall at Tuttle Crossing story is completely made up—despite what your friends might tell you. Regardless of how much they try to convince you otherwise, there is not a single documented event at this particular mall remotely similar to the incident described.

It's unclear why this particular legend chose to make the Mall at Tuttle Crossing its home, but it should be noted that when the mall first opened its doors in 1997, it became the Columbus area's first new suburban mall in thirty years. That newness and excitement may have made the mall the perfect setting for an urban legend to come home to roost.

Sadly, in late 2010, an incident took place near the Mall at Tuttle Crossing that some erroneously attached to the kidnapping urban legend, despite the fact that this event took place over a decade after the urban legend started making the rounds.

On December 26, 2010, after spending the day checking out some after-Christmas specials at the mall, thirty-year-old Carolina Alba Martinez de Acosta and her husband, Erick, exited the mall near the food court and walked out to their SUV. After putting their purchases into the trunk, the couple left the mall, with Erick behind the wheel.

Roughly a half mile away from the mall, heading south on Camden Place Drive, the couple slowed as they approached the intersection with Hayden Run Road. It was there that, allegedly, two teenagers jumped into the Acostas' vehicle, put a gun to Erick Acosta's head and ordered him to drive.

Acosta did as he was told and drove for several miles until the teens ordered him to stop the car along Langton Road. The teens exited the vehicle, at which point Acosta attempted to drive off. As he did, one of the teens allegedly fired twice, striking Carolina in the head. She later died at the hospital.

While this tragic tale is sometimes incorporated into the Tuttle Mall abductor urban legend, there are quite a few glaring differences. For one, the urban legend always has a single woman being approached/abducted by a solitary male. In this case, Acosta was with her husband, and there were two abductors involved. Finally, while the urban legend centers on the parking lot of the mall, that is not where the incident involving the Acostas took place. It is true the Acostas had been shopping at the Mall at Tuttle Crossing, but they were not on mall property when the attack took place. However, in a case of urban legends mirroring true events (or in this case, visa versa), as of this writing, no arrests have been made in the case, and Acosta's killer remains at large.

The Mall at Tuttle Crossing isn't the only Central Ohio mall attached to an urban legend involving homicidal maniacs. There's also the Polaris Fashion Place mall, which opened in 2001. It took more than a decade for this mall to gain its very own urban legend. But thanks to the Internet and e-mail, when this one hit, it spread like wildfire.

This particular legend, which seems to have first attached itself to Polaris Fashion Place mall in late February 2014, revolved around the urban legend of street gangs initiating new members by forcing them to assault, kidnap, rape and kill random women. In the past, this legend was passed around by word of mouth. But in the case of the Polaris Fashion Place mall variation, it spread via e-mail.

The original post was from someone who claimed that a "co-worker's cousin" had been kidnapped from the Polaris Fashion Place mall "on Saturday," in broad daylight. It continued by stating that this abduction was part of a large-scale operation targeting "younger/thinner/lighter hair/lighter eyes/lighter skin females" walking alone, although "this group has also abducted groups of young women traveling together and women with daughters."

The e-mail, which was unsigned and bore no specifics as to who wrote it and no details about any specific crime, was quickly forwarded throughout Central Ohio by concerned citizens, who were no doubt spurred on by the e-mail's request to "please forward this to everyone you know."

There was one major problem, though: The alleged event never took place. In fact, when the *Columbus Dispatch* asked Columbus police sergeant David Pelphrey for a comment, he said the whole thing "is right up there with Bigfoot." While they didn't invoke everyone's favorite cryptid, Polaris officials did go on record to state that they had no reports of abductions or attempted abductions.

How did this particular urban legend get started? It's hard to say, although it has been reported that a local school official received the original e-mail and then, believing it was real, forwarded it to his staff. Once the e-mail had a "legitimate" individual forwarding it along, it suddenly became "real."

Let's recap: Despite what your friends and e-mails might tell you, the malls of Central Ohio are safe and ready to meet all your shopping needs. Of course, hidden deep within every urban legend is a little nugget that warns against doing something that could get you in trouble. In this case, it's a cautionary tale about always being aware of your surroundings, lest you fall victim to foul play. True or not, these tales offer some sage advice that should be heeded, regardless of where you are.

A WOOLY WHAT?

ADVENTURES INSIDE
WOOLYBURGER CEMETERY

It's officially listed as the Little Pennsylvania Cemetery, a quiet little cemetery off London-Groveport Road, nestled along Big Darby Creek. No one ever calls it by its official name, though. In fact, most locals refer to it as Woolyburger Cemetery and claim that it marks the spot where, for decades, ghostly girls, homicidal maniacs, red-eyed monsters, satanic cults and all sorts of weird stuff have come crashing together. Before we get to the good stuff, we simply can't ignore one issue any longer: Where did the name "Woolyburger" come from?

Answering that is not as easy as it would seem. Truth be told, most people have no idea where the name came from. Those I interviewed who claimed to know the origin said that it came from a Bigfoot-like creature known as the Woolyburger that's believed to live at the back of the cemetery. There's only one problem: I've yet to uncover any reference to a creature called a Woolyburger, either at this cemetery or anywhere else in the world, for that matter.

There is, however, a strange creature known as a Wooly Booger that is said to resemble Bigfoot. The Wooly Booger pops up in legends and folktales in states like Virginia, Texas and Florida. To date, I have yet to find any reference to a Wooly Booger in Ohio folklore, but given the claims of a similar creature living in the woods around Little Pennsylvania Cemetery, it would stand to reason that the Woolyburger name resulted from a misheard "Wooly Booger."

Woolyburger Cemetery, home to more urban legends than you can shake a ghostly stick at. *Author photo.*

More evidence pointing to the reason the nickname of the cemetery is Woolyburger concerns the fact that a portion of Big Darby Creek runs alongside the cemetery, making the area quite popular with fishermen. And there is a fly-fishing lure that's known as, you guessed it, a "Woolybooger." It would seem that there's a pretty good possibility the cemetery's nickname derived from this term.

Not so fast, though. One of the longest-standing ghost stories associated with the cemetery involves a man by the name of Willie Butcher. Some say that the mispronounciation of Butcher's name led to the cemetery getting its odd moniker. True or not, it cannot be disputed that the name "Willie Butcher" is the one that springs to mind whenever people start talking about ghosts in the cemetery. That's because, according to legend, Butcher once lived in a house directly across from the cemetery with his wife and family. For reasons that are not entirely clear, Willie snapped one evening and murdered his family with a knife, thereby living up to his name. When all was said and done, Willie turned the knife on himself and committed suicide.

After the murders, the Butcher house stood empty for many years. And it didn't take long for the stories of the Butcher family haunting the abandoned abode to start circulating through the area. Those brave enough to make their way inside the dilapidated house often reported catching glimpses of the murdered family's ghosts wandering the halls. Even more disturbing were the stories of people seeing the ghost of Willie Butcher lurking in the darkness, still brandishing a knife.

The house was said to have fallen into disrepair, and it was eventually torn down, leaving nothing but an old foundation behind. Legend has it that it was around this time that the ghosts of the Butcher family, including the knife-wielding Willie, strolled across London-Groveport Road and took up residence in the Little Pennsylvania Cemetery, where they had all been buried. They are allegedly still there, as people report hearing agonizing screams and cries, as if that murderous night is being replayed over and over. Of all the Butcher ghosts, Willie's is seen most frequently, peering out from behind trees and tombstones, often with what appear to be red, glowing eyes. Willie's daughter is also often seen in the cemetery. Described as wearing an all-white dress, she is often spotted walking through the cemetery late at night or simply standing over the family graves.

There is one problem with this story, however. No one with the last name "Butcher" is buried in Little Pennsylvania Cemetery. There are a few family members with the last name "Boucher," including a Willie Boucher. Some people contend that Boucher, like every other name associated with this cemetery, was misheard and that Willie Boucher is the real name of the murderer/ghost. Of course, in order to believe that, one has to accept the fact that Willie was able to murder his entire family at the tender age of ten months. According to Willie Boucher's tombstone, he died in January 1865, two months shy of his first birthday.

Another ghost often associated with the Willie Butcher legend is the one commonly known as the "Little Girl in White." Often seen wandering the cemetery at night, this mysterious specter is usually said to be one of Willie Butcher's victims, namely one of his daughters. In recent years, possibly due to the discovery of the "truth" behind the Willie Butcher tale, this ghostly girl acquired a new, totally different backstory. Locals now say that the girl serves as a grim reminder of an event that took place years ago near the small pond located in the woods behind the cemetery. It is said that the girl was raped and murdered by a group of men near the water's edge. Afterward, her body was disposed of in the pond, where it allegedly still is today. There are no historical accounts or documentation to verify that such

The grave of Willie Boucher. Some people would have you believe he is the world's youngest mass murderer. *Author photo.*

an event ever took place, but that has done nothing to stop the tale from being told by thrillseekers everywhere.

Of course, ghosts aren't the only things lurking in the area. People visiting the Old Pennsylvania Cemetery at night (which is illegal, by the way; all Ohio cemeteries are closed from dusk until dawn) have reported stumbling upon a group of robed figures conducting some sort of foul, satanic ritual. Once spotted, the shadowy figures often run off into the woods. In some instances, though, they allegedly make threatening gestures at those who were unlucky enough to witness their secret ritual. There are reports of people being chased back to their cars by the unknown individuals. Disembodied screams are also sometimes heard coming from the woods. The screams are said to belong to former (or current) victims of this cult, crying in terror as unspeakable acts are committed.

Last, and certainly not least, are the red, glowing eyes people see moving about in the woods. These eyes are usually said to be related to a demon (or

the devil himself) conjured up by one of the cult's rituals. Others, however, say the eyes are not those of a demon at all, but rather of the Bigfoot-like creature the cemetery was named after. And some think the red "eyes" are nothing more than the LED lights from late-night fishermen hanging around Big Darby Creek.

That's a lot of legends stuffed into one place, isn't it? Are there creepy things lurking out there? It's hard to say. On the one hand, there is very little, if any, evidence to support the occurrence of the alleged events. Unless, of course, one is willing to accept that someone can become a bona fide serial killer before the age of one. Yet these stories have endured for decades and show no signs of going away. With that in mind, I think we can all safely assume that the Old Pennsylvania Cemetery is not planning on giving up its secrets anytime soon.

SELECTED BIBLIOGRAPHY

Akers, Merton T. "William Quantrill Pays Off His Grudge Against Town with Blood, Fire." *Lebanon Daily News*, August 21, 1963.

Akron Beacon Journal. "Expects to Show Pierson Was Tied." November 1, 1905.

———. "Hunters Not Intimidated by Threat of Serial Killer." August 31, 1992.

———. "Order of Events Leading to Confession." July 4, 1993.

———. "Police Searching for Lion." May 5, 2004.

———. "Sculpture to Be Dedicated." March 16, 1990.

American Experience: Annie Oakley. Riva Freifeld. DVD. American Experience Films, 2006.

Arizona Daily Star. "Guerrilla Leader William Quantrill Is Reburied by Confederate Group." October 25, 1992.

Baher, William J. *Centennial History of Coshocton County, Ohio*. Vol. 1. Chicago: S.J. Clarke, 1909.

Baltimore Sun. "Adam Horn, His Identity as Andrew Hellman." April 24, 1843.

———. "Andrew Hellman, Alias Adam Horn: His Life Character and Crimes." December 2, 1843.

———. "Arrest of the Murderer, Adam Horn." April 22, 1843.

———. "Bust of Adam Horn." January 26, 1844.

———. "Execution of Adam Horn." December 11, 1843.

———. "Head of Malinda Horn Found." May 27, 1843.

———. "Local Matters: A Chase, Probable Escape of Horn." April 21, 1843.

———. "Local Matters: Horrible Murder in Baltimore County." April 19, 1843.

———. "Look Out for Him." November 27, 1840.

———. "Trial of Adam Horn, for Murder." November 23, 1843.

Beck, William, Leroy Bonner, Marshall Jones, Ralph Middlebrooks, Marvin Pierce, Clarence Satchell and James Williams. "Love Rollercoaster." On *Honey*, The Ohio Players. LP. Chicago: Mercury Records, 1975.

Belmont Chronicle. "Brutal Murder of a Girl 14 Years of Age." January 28, 1869.

———. "On Saturday Night Thomas Carr, the Murderer of Louisa Fox, Made an Attempt to Break Jail." February 11, 1869.

Billboard 200: Week of September 27, 1975. Accessed March 15, 2016. http://www.billboard.com/charts/billboard-200/1975-09-27.

Birnes, William J. *UFO Magazine UFO Encyclopedia*. New York: Pocket Books, 2004.

Blakeslee, Alton. "Unidentified Flying Objects Held Possible but Can't Be Confirmed." *Post-Crescent*, April 19, 1967.

Booker, John H. "Andy Is Bull with 4 Eyes, 2 Extra Horns." *Tucson Daily Citizen*, January 16, 1945.

Bowles, Scott. "Human Prey: Murderer's Gunfire Targeted Hunters." *Detroit News and Free Press*, January 31, 1993.

Brooklyn Daily Eagle. "Execution of Adam Horn." January 16, 1844.

Brooklyn Evening Star. "Adam Horn Found Guilty of Murder in the First Degree." November 29, 1843.

Brunvand, Jan Harold. *Encyclopedia of Urban Legends*. New York: W.W. Norton & Company, 2001.

Bucks County Gazzette. "Aboriginal Fragments: Execution of a Wyandot for Witchcraft." September 16, 1875.

Carey, Thomas J., and Donald R. Schmitt. *Inside the Real Area 51: The Secret History of Wright-Patterson*. Pompton Plains, NJ: New Page Books, 2013.

Cauchon, Dennis. "If It's a Lion, Ohio Hopes It's a Fraidy-Cat." *USA Today*. Accessed August 2, 2016. http://usatoday30.usatoday.com/news/nation/2004-05-04-lion-usat_x.htm.

CBS News. "Lion on the Loose in Ohio." Accessed August 1, 2106. http://www.cbsnews.com/news/lion-on-the-loose-in-ohio.

Chicago Tribune. "Inquiry Proves Student Was Tied." November 12, 1905.

———. "Urban Legend of 'Mall Slasher' Just Won't Die." Accessed August 25, 2016. http://articles.chicagotribune.com/1991-10-11/news/9104010893_1_initiation-rite-aurora-gangs.

Cincinnati Enquirer. "Council of Real Red Men Held on Campus of Ohio State University." October 13, 1911.

———. "Divers Hunting the Revolver with Which Bessie Little Was Shot." September 7, 1896.

———. "Gahanna Lion Reported Roaming 13 Miles Away." July 10, 2004.

———. "Gahanna's Lion King May Be on the Roam." July 10, 2004.

———. "Seemingly Devoid of Any Feeling, Albert Frantz Answered 'Not Guilty' When Formally Charged with Bessie Little's Murder." September 12, 1896.

———. "St. Clairsville: The Execution of Thomas D. Carr." March 25, 1870.

Clemens, Will M. "Tributes to Indians: Monuments Erected by the Whites to Commemorate Famous Chiefs." *Evening Star*, August 27, 1905.

Coleman, Loren. *Bigfoot! The True Story of Apes in America.* New York: Pocket Books, 2003.

Coleman, Loren, and Jerome Clark. *Cryptozoology A to Z.* New York: Fireside, 1999.

Coleman, Loren, and Patrick Huyghe. *The Field Guide to Bigfoot and Other Mystery Primates.* San Antonio, TX: Anomalist Books, 2006.

Columbus Dispatch. "Police Say It's Safe to Ignore That Email on Mall Abductions." Accessed September 1, 2016. http://www.dispatch.com/content/stories/local/2014/03/06/Police_rank_mall_abduction_rumors_with_bigfoot_tales.html.

———. "Tuttle Mall Not So Special Anymore." Accessed November 15, 2016. http://www.dispatch.com/content/stories/business/2013/07/05/tuttle-mall-not-so-special-anymore.html.

Columbus Evening Dispatch. "Life of T.T. Tress Snuffed Out by a Sad Accident." April 28, 1904.

"Columbus Mileposts: Feb. 28, 1930—Ohio State Prof Executed as Adulterer-Turned-Killer." Accessed December 18, 2016. http://www.dispatch.com/content/stories/local/2012/02/28/osu-prof-executed-as-adulterer-turned-killer.html.

Conservative. "Thomas D. Carr, His Murderous Record." April 1, 1870.

Cook County Herald. "Find Bloodstained Rope." November 10, 1905.

Coshocton County Beacon. "The Coshocton Pygmies." February 23, 2011.

Coshocton Tribune. "Mystery Surrounds Burial Ground at Rock Run." March 22, 1924.

———. "Snook Dies Without Flinching." March 1, 1930.

Culver Citizen. "Students Face Murder Charge." November 9, 1905.

Daily Chronicle. "Sasquatches Are 'No-No' Now." July 22, 1971.

Daily Herald. "Bessie Little's Fate." September 8, 1896.

———. "Charge of Murder: Albert Frantz Held Accountable for Bessie Little's Death." September 11, 1896.

Daily Jeffersonian. "Gahanna Lion May Be on the Move; Sighting Reported 13 Miles Away." Accessed August 1, 2016. http://www.daily-jeff.com/local%20news/2004/07/09/gahanna-lion-may-be-on-the-move-sighting-reported-13-miles-away.

Daily Reporter. "Let's Tour Ohio." June 15, 1968.

Daily Times. "Burial Site of Chief Leatherlips Sought." October 6, 1932.

———. "Deny Quantrill Is Buried in Dover." May 9, 1922.

Davis, Lauren. "13 Places on Earth People Believed Were Entrances to Hell." Accessed July 12, 2016. http://io9.gizmodo.com/13-places-on-earth-thought-to-be-entrances-to-hell-1441628317.

Dayton Unknown. "Hills and Dales Lookout Tower: The REAL Story." Accessed November 4, 2017. https://daytonunknown.wordpress.com/2014/05/16/hills-and-dales-lookout-tower-the-real-story.

Defiance Democrat. "Death of Leather-Lips the Wyandotte Chief." July 29, 1871.

Detroit Free Press. "Annie Oakley Dies in Ohio; Was Long Ill." November 5, 1926.

Disney's American Legends. Walt Disney Home Video, 2002. DVD.

Downing, Bob. "Hoping to Meet the Beast: Bigfoot Buff Has No Time for Skeptics." *Akron Beacon Journal*, September 6, 1988.

Eberhart, George M. *Mysterious Creatures: A Guide to Cryptozoology*. Santa Barbara, CA: ABC-CLIO, Sterling Publications, 2002.

Ellis, Ashley Williams. "Wind through Wyandot History." *Cincinnati Enquirer*, July 20, 2008.

Ethridge, Mary. "Mystique Helps Kenmore Keep Its Identity." *Akron Beacon Journal*, January 29, 2001.

Eureka Humboldt Standard. "Huge Footprints Found on Wilderness Road." October 6, 1958.

Evening News. "Indians Were Pygmies or Else Cut Off Legs." April 18, 1924.

Evening Review. "Tied to Railroad Track." October 31, 1905.

Fairfield County Historical Parks. "Stonewall Cemetery." Accessed June 14, 2016. http://www.historicalparks.org/stonewall-cemetery.

Fenner, Laura. "Shiloh Woman Has His Autograph, Recalls Tales of Johnny Appleseed." *News-Journal (Mansfield, OH)*, August 10, 1952.

"Force Fact Sheet: Unidentified Flying Objects and Air Force Project Blue Book." Accessed June 23, 2016. http://archive.is/20120719123429/http://www.af.mil/information/factsheets/factsheet_print.asp?fsID=188&page=1#selection-69.0-77.108.

Galloway, Barbara. "Did Minerva Area's Big Foot Step Out of a Flying Saucer?" *Akron Beacon Journal*, May 17, 1982.

———. "Does Bigfoot Stalk Near Newcomerstown?" *Akron Beacon Journal*, July 29, 1985.

Garber, D.W. "Stories of Old 'Leatherlip' Kept Pioneers' Kids in Line." *News-Journal*, October 26, 1958.

Geiling, Natasha. "The Real Johnny Appleseed Brought Apples—And Booze—to the American Frontier." Accessed December 4, 2016. http://www.smithsonianmag.com/arts-culture/real-johnny-appleseed-brought-applesand-booze-american-frontier-180953263/?no-ist.

Genealogy Bug: Little Pennsylvania Cemetery. Accessed September 25, 2017. http://www.genealogybug.net/Franklin_Cemeteries/lttlpenna/lttlpenna.html.

Gettysburg Compiler. "Horrible Murder Near Baltimore." May 1, 1843.

Ghost Hunters. "Time to Get Touched." Season 6, part 2. Big Vision, 2011.

Goldberg, Al. "Official Air Force Belief: No Flying Saucers." *San Antonio Express*, August 29, 1965.

Goulder, Grace. *This Is Ohio*. New York: World Publishing Company, 1965.

Gribben, Mark. *The Professor & the Coed: Scandal & Murder at the Ohio State University.* Charleston, SC: The History Press, 2010.

Gross, W.H. "A Time of Terror: The Ohio Sportsman Murders." Accessed July 21, 2016. https://www.nrafamily.org/articles/2016/2/18/a-time-of-terror-the-ohio-sportsman-murders.

"Hills and Dales Metroparks." Accessed November 12, 2016. http://www.metroparks.org/places-to-go/hills-dales.

Hocking Sentinel. "What a Fool I Am." May 5, 1904.

"How Much of Your State Is Wet?" Accessed December 5, 2016. http://water.usgs.gov/edu/wetstates.html.

Indiana Herald. "Daring Raid of Guerrillas in Kansas." August 26, 1863.

Indianapolis Star. "Black Hand Takes Up Stuart Pierson Case." November 20, 1905.

Jeffersonian (Stroudsburg, PA). "History of Horn." January 4, 1844.

Johnson, Alan. "Fewer Wild Animals Being Kept by Ohioans in Wake of 2012 Law." *Columbus Dispatch*. Accessed August 2, 2016. http://www.dispatch.com/content/stories/local/2016/02/14/ohio-moving-slowly-away-from-wild-animals-business.html.

Joliet Signal. "From Leavenworth." August 25, 1863.

JShonk's Lost Ohio. "Stonewall Cemetery in Lancaster." Accessed June 14, 2016. http://www.jshonk.com/blogs/stonewall-cemetery-lancaster-ohio.

Kastel, Albert. "Civil War Days." *Courier-Journal*, February 19, 1961.

Keener, Doris. "Quantrill's Gone but Not Forgotten." *Daily Reporter*, June 9, 1971.

Klosterman, Chuck. "Bigfoot Believers." *Akron Beacon Journal*, March 24, 1999.

Knauss, William H. *The Story of Camp Chase: A History of the Prison and Its Cemetery, Together with Other Cemeteries Where Confederate Prisoners Are Buried, Etc.* N.p.: Publishing House of the Methodist Episcopal Church, 1906.

Knox, David. "Stark Man Is Suspect in as Many as 11 Deaths." *Beacon Journal*, December 3, 1992.

Knox, David, and Jolene Limbacher. "Suspect in Killings Boasted of Violence." *Akron Beacon Journal*, December 9, 1992.

Kohn, David. "A Sniper's Mind." CBS News. Accessed July 12, 2016. http://www.cbsnews.com/news/a-snipers-mind.

Lancaster Eagle-Gazette. "New Straitsville Mine Fire Still Plagues Perry Town." January 3, 1959.

Lewis, Valda. *Devil's Oven: The Fire in the Heart of the Little Cities of Black Diamonds.* Valda Lewis/Goodwin Video & New Media, 2007. DVD.

Limbacher, Jolene. "Dillon Shocked at List of Crimes Laid to Him." *Akron Beacon Journal*, April 4, 1993.

Little, Richard Henry. "Inquiry Proves Student Was Tied." *Chicago Tribune*, November 12, 1905.

Logan Daily News. "Johnny Appleseed Left Ohio Heritage in Apple Orchards." September 23, 1960.

———. "Tours Planned: Fire & Foliage Jubilee Set at New Straitsville." October 10, 1974.

———. "World-Famous Straitsville Mine Fire Still Smoldering after 84 Years." February 17, 1968.

Marion Daily Star. "Is Tied to Rails." November 11, 1905.

Martin, Chuck. "Bigfoot in Clermont County?" *Cincinnati Enquirer*, October 31, 2007.

McGuire, Donna. "Civil War Guerrilla's Burial Starts New War." *Detroit Free Press*, October 20, 1992.

Monsterquest. "Ohio Grassman." Season 2. A&E Home Video, 2009.

Monsters & Mysteries in America. "Ohio Grassman." Season 2, episode 7. Destination America, January 26, 2014.

Moody, Minnie Hite. "Coshocton's Pygmy Graves." *Newark Advocate*, July 4, 1975.

Mountain Monsters. "Grassman of Perry County." Season 1, episode 2. Destination America, June 29, 2013.

———. "Grassman's Revengeance." Season 2, episode 14. Destination America, July 25, 2014.

———. "Return of the Rogue Team." Season 4, episode 12. Destination America, April 9, 2016.

Murphey, Christopher L. *Bigfoot Encounters in Ohio: Quest for the Grassman.* Blaine, WA: Hancock House Publishers, 2006.

Murphey, Fran. "Museum Combines History and Holiday." *Akron Beacon Journal*, December 11, 1983.

"National Cemetery Administration: Camp Chase Cemetery." Accessed April 27, 2016. http://www.cem.va.gov/cems/lots/campchase.asp.

National Park Service. "Not to Be Forgotten: Camp Chase Confederate Cemetery." Accessed April 28, 2016. https://www.nps.gov/Nr/twhp/wwwlps/lessons/123camp_chase/index.htm.

News Journal. "Annie Oakley Arrested." August 12, 1903.

New York Times. "Kenyon's President Defends His Students." November 26, 1905.

O'Connor, Bill. "A Burial of Shame?" *Akron-Beacon Journal*, November 22, 1992.

Ohio Democrat. "Birth-Place of Quantrill." November 20, 1863.

Ohio State Parks & Watercraft. "Salt Fork State Park." Accessed December 2, 2016. http://parks.ohiodnr.gov/saltfork.

Ottawa Herald. "Seek Guerilla's Body." May 9, 1922.

Philadelphia Enquirer. "Monument to Leatherlips, an Indian Chief." November 10, 1901.

———. "Tecumseh Was Jealous." April 22, 1923.

Piqua Daily Call. "President Explains: Head of Kenyon College Gives Details of Pierson Case." November 15, 1905.

Pittsburgh Press. "Scripps-Howard Artist Tells Story of Dr. Snook's Confession of Hix Murder." June 23, 1929.

Pittsburgh Weekly Gazette. "Execution of Adam Horn." January 19, 1844.

Pollock, Mabel V. "Last of the Pygmies." *Columbus Dispatch* magazine, June 8, 1975.

Press-Gazette. "Monument Marks Death Leatherlips." October 20, 1976.

Public Ledger. "Trial of Horn for Murder." November 25, 1843.

Reading Times. "Western Miners' War." March 20, 1875.

Richter, Darmon. "11 Hidden Spots to Enter the Underworld." Atlas Obscura. Accessed November 1, 2016. http://www.atlasobscura.com/articles/11-hidden-spots-to-enter-the-underworld.

Ruppelt, Edward J. *The Report on Unidentified Flying Objects*. Lexington, KY: Pacific Publishing Studio, 2011.

Schleis, Paula. "Jeepers Creepers, He's Got His Eyes Out for Creatures." *Akron Beacon Journal*, October 29, 2001.

Scientific Study of Unidentified Flying Objects. Accessed December 1, 2016. http://files.ncas.org/condon/index.html.

Seymour, Seth. "No Lion, but Lots of Rumors; Big Cat on Prowl?" *Columbus Dispatch*, November 14, 2004.

Sharp, Paul. "Quantrill: Mysterious Quirk Turns Him from Teaching to Terrorism." *Daily Reporter*, August 22, 1964.

Snopes.com. "Hairy-Armed Hitchhiker." Accessed September 1, 2016. http://www.snopes.com/horrors/madmen/hairyarm.asp.

Speigel, Mary Jo. "Old House Features Ohio Oddities." *Cincinnati Enquirer*, March 2, 2007.

Spirit of Democracy, The. "Death Sentence of Thomas D. Carr." July 6, 1869.

———. "Proceedings of Common Pleas Court: Acquittal of Kennon— Carr Convicted of Murder in the First Degree." June 29, 1869.

Stall, Sam. *Suburban Legends: True Tales of Murder, Mayhem, and Minivans*. Philadelphia, PA: Quirk Books, 2006.

Stanfield, Virgil A. "Johnny Appleseed Liked to Roam City Area." *News-Journal (Mansfield, OH)*, August 15, 1971.

Stark County Democrat. "Almost a Suicide." September 15, 1869.

Steiger, Brad, ed. *Project Blue Book*. New York: Ballantine Books, 1976.

Tennessean. "Fresh Troubles Among the Hocking Fires." June 26, 1874.

10tv.com. "Dublin Police Investigating Woman's Shooting Death." Accessed November 15, 2016. http://www.10tv.com/article/dublin-police-investigating-womans-shooting-death.

———. "Sheriff: Woman Shot, Killed After Apparent Carjacking." Accessed November 15, 2016. http://www.10tv.com/article/sheriff-woman-shot-killed-after-apparent-carjacking.

———. "Woman Carjacked, Shot to Death at Tuttle Mall." Accessed August 16, 2016. http://www.10tv.com/article/woman-carjacked-shot-death-near-mall-may-have-been-targeted.

Thurber, James. *My Life and Hard Times*. New York: Harper Perennial Modern Classics, 1999.

Times Recorder. "Hunt Grave of Old Leatherlips." October 5, 1932.

Washington Post. "Lies About Tragedy: Kenyon President's Version of Student's Death." November 14, 1905.

Watson, Elmo Scott. "The First 'America's Sweetheart.'" *St. Clair Chronicle*, November 24, 1937.

———. "Proposed Memorial to Annie Oakley Fails but She Remains Enshrined in the Hearts of Thousands of Americans." *Statesville Daily Record*, November 24, 1939.

Weekly Register. "Leatherlips Grave." July 6, 1898.

Willis, James A. *The Big Book of Ohio Ghost Stories*. Mechanicsburg, PA: Stackpole Books, 2013.

Willis, James A., et al. *Weird Ohio*. New York: Sterling Publications, 2005.

Wilmington News-Journal. "Lightning Kills Girl, Injures Boy Companion." May 19, 1967.

———. "Monument Marks Death of Leatherlips." October 23, 1976.

Wolfe, Henry C. "The Little People." *Saturday Review*, November 7, 1964.

———. "Sketch of Coshocton History and the Founding of Johnson-Humrickhouse Memorial Museum: City Has Always Held Important Place in History of Ohio." *Coshocton Tribune*, May 3, 1931.

Wyandotte Gazette. "Lawrence Burned!" August 29, 1863.

Xenia Daily Gazette. "Albert Frantz: Now on Trial at Dayton." December 15, 1896.

———. "Bellbrook Girl Thought Killed Lightning Bolt." May 18, 1967.

———. "Bessie Avenged." November 19, 1897.

———. "Sugarcreek Youth Recovers from Burns." June 6, 1967.

Xenia Sentinel. "The Burning of Lawrence." August 25, 1863.

Zanesville Signal. "Snook or Meyers May Be Charged with Co-Ed's Murder." June 17, 1929.

ABOUT THE AUTHOR

James A. Willis has been walking on the weird side of history for over thirty years. When not out chasing after all things strange and spooky, Willis found the time to author over a dozen books, including *Ohio's Historic Haunts: Investigating the Paranormal in the Buckeye State*, *Haunted Indiana* and *Weird Ohio*.

A sought-after public speaker, Willis has given presentations throughout the United States, during which he has educated and entertained tens of thousands of people of all ages in crowd sizes ranging from ten to well over six hundred. He has also been featured in more than seventy-five media sources, including *CNN*, *USA Today*, *Columbus Business First*, *Midwest Living*, the *Canadian Press* and even the *Kuwait Times*.

Willis currently resides in Galena, Ohio, with his wife and daughter, a Queen-loving parrot and three narcoleptic cats. He can often be found lurking around his virtual abode, strangeandspookyworld.com.